LOVE & SCIENCE

LOVE & SCIENCE

SELECTED MUSIC-THEATRE TEXTS

RICHARD FOREMAN

THEATRE
COMMUNICATIONS
GROUP

Love & Science is supported in part by a grant from the Opera-Musical Theater Program of the National Endowment for the Arts.

TCG gratefully acknowledges public funds from the National Endowment for the Arts and the New York State Council on the Arts in addition to the generous support of the following foundations and corporations: Alcoa Foundation; Ameritech Foundation; ARCO Foundation; AT&T Foundation; Citibank; Consolidated Edison Company of New York; Nathan Cummings Foundation; Dayton Hudson Foundation; Exxon Corporation; Ford Foundation; James Irvine Foundation; Jerome Foundation; Andrew W. Mellon Foundation; Metropolitan Life Foundation; National Broadcasting Company; Pew Charitable Trusts; Philip Morris Companies; Scherman Foundation; Shubert Foundation.

Photographs on pages 90 and 110 by Babette Mangolte.
all other photographs by Clemens Kalischer.

Silverman, Stanley.
[Musicals. Selections]
Love & science : selected music-theatre texts / Richard Foreman.
Music for the 1st-3rd works by Stanley Silverman; the 4th work is unset.
Contents: Hotel for criminals : the American imagination — Africanus instructus — Love & science — Yiddisher teddy bears.
ISBN 1-55936-021-6 (paperbound)
1. Musicals—Librettos. I. Foreman, Richard. II. Title: Love & science.
ML49.S53F7 1991
782.1'4'0268—dc20 90-29042 CIP MN

Design and composition by The Sarabande Press

First Edition, August 1991

CONTENTS

BRIGHTLY LIT
CRYSTAL CHANDELIERS

RICHARD FOREMAN ON MUSIC-THEATRE

Interviewed and Edited by Steven Samuels

Musicals must ravish the sensibilities. While mine are not produced for mass audiences, I think of them as closer to commercial theatre than my straight plays. Whereas I hope my straight plays will actually alter the audience's consciousness, I intend my musicals simply to enter the existing (if limited) repertory of provocative and witty twentieth-century works.

The process of creation reflects different intentions in the cases of my musicals and plays. When I generate texts for a play, I try to write out of a state of forgetfulness, simply noting scraps of consciousness, but the musicals are written with much more conscious control. With a musical, I sit down one day—after procrastinating as any writer does—and write straight through from beginning to end. Since much of the text assumes song form, I work within the technical demands of scannable rhymed verse.

These disparate approaches reflect an early decision to devote half my time to my own admittedly "difficult" plays and half to more accessible efforts. I hoped simultaneously to create the world's most outrageous avant-garde theatre and to take "time off" to create and direct in more commercial arenas.

My dream, however, was to create music-theatre that, while accessible, created an atmosphere of poetic mystery, that sort of mystery that often arises in the first twenty minutes of a normal narrative mystery or adventure movie. For me, those first twenty minutes are most fascinating because it's still not clear exactly what's going on. Will there be a murder? Is that guy really a villain? How is *he* related to *her*? That's when I'm most involved. As possibilities are eliminated—when I realize *he*'s the murderer and *he* hates *her*—I start looking at my watch.

Imagining a musical, I first consider a locale, or an atmosphere that

suggests a particular kind of music. Writing plays, I'm interested in establishing points in the landscape across which the sparks of the observer's consciousness must arc. The arcing of those sparks from point to point, moment to moment, word to word, image to image, is the lifeblood of the plays, as it is in much contemporary poetry. The task is to make those nodule points as far apart as possible so that the sparks of consciousness, jumping large gaps, become big and beautiful, awakening the spectators' deep self.

The plays are about the music of those sparks and the length of those jumps. The equivalent energy in my music-theatre works is in the songs. I don't insist upon conceptual gaps nearly as large for the mind to jump across in my musicals. In the musicals, I want to lead the audience gently to the gap of ecstatic abandonment, embodied in song, rather than (as in my plays) pushing them to the edge of a cliff and counting upon their own inner energy to carry them across.

The first show I ever saw was *The Red Mill*, when I was maybe seven. When a performer came out and sang "Every Day Is Ladies' Day for Me," my sister and I nudged my mother excitedly because we thought the singer was staring right at us (which may have been the source in later years for characters in my shows staring straight at the audience).

Then, when I was in the fourth grade, my grandmother took me to see Harold Rome's musical *Call Me Mister*, and I performed a lip-synch version of it for my grade-school class. In the fifth and sixth grades I moved up to *The Pirates of Penzance* and *The Mikado*: staged them, created the scenery, and played the leading roles.

That was my start in the theatre. I was taken to a whole season of the D'Oyly Carte operas when they first came to New York, and it was like being in love. I couldn't eat. I couldn't sleep. I managed to avoid a piano lesson by saying I was too upset because the D'Oyly Carte company was leaving town that week. I made drawings of all of the actors, mailed them to the theatre, and was invited backstage to meet the cast.

In those days my grandmother belonged to the Theatre Guild and I went to Saturday matinees with her. The Theatre Guild musicals tended to be somewhat more adventurous than other producers' presentations. Even in the early Fifties, when I was fourteen or fifteen, I didn't like the usual hits but rather the more bizarre moments of shows that never really "made it."

Of the accepted successes, I liked *Gentlemen Prefer Blondes* best. Its Twenties style seemed bizarre and energetic; it was the most stylized musical of its time. I was *very* disappointed in *Guys and Dolls*—I thought it wasn't raunchy and rough enough. I liked *Paint Your Wagon* much better than *My Fair Lady*, for example, because *Paint Your Wagon* was rough and lively, which it seemed to me was all that a musical should be.

When my parents took me to the original production of *South Pacific*, I was unimpressed. I hated all Rodgers and Hammerstein musicals. They seemed sappy calendar art. I only liked the fast, lively songs and became impatient when the plot got in the way. I could never understand why they didn't just sing and dance a lot more.

Revues entertained me. What troubled me most about story-oriented American musicals was their pretentiousness, their aspiration to be what Dwight Macdonald called "mid-cult, middle-brow art." I preferred a musical—if it was going to be a musical—low-down, fast, lively and eccentric.

I listened to opera, too, at that time. I remember being very impressed with Gian Carlo Menotti's *The Consul* when I saw it on Broadway, thinking that Menotti—aside from his music—was a wonderful stage director. To my fifteen-year-old eyes, *The Consul* looked much more imaginatively staged than most of what I saw on Broadway.

Of course more radically *serious* music-theatre, like the original production of *Lost in the Stars*, made a big impression on me. Years later, in a mediocre revival, *Lost in the Stars* seemed dreadful, but the original production—which used two photorealist backdrops, one of the countryside in South Africa and one of a city—was very important to me. The whole production had a Piscator-like

feel, however watered down, but when it was revived the sets were poetically spacey—American Ballet Theatre style—the direction was equally "artsy," and Weill's great music was sapped of all its abrasive energy.

Of course my most significant music-theatre influence was the work of Brecht and Weill. When I was in my early teens I heard a recording of the original German *Threepenny Opera*, and it was a total revelation, the most wonderful music I'd ever heard, evoking a theatrical energy that dominated the next twenty years of my life. During my undergraduate years at Brown University, Columbia Records brought out *The Rise and Fall of the City of Mahagonny*, which I considered the greatest event in the history of twentieth century music-theatre. I put signs up all over the campus announcing that I would be playing this magnificent recording in the lounge of the Student Center on a particular Tuesday. Only three people showed up. I was crushed (and introduced to reality).

At Brown University, then as a graduate student at Yale and then when I moved to New York City, I wrote straight plays. I wasn't thinking about musicals at all until the day my ex-wife, Amy Taubin, and I ran into the singer Mary Delson—whom Amy had known at Sarah Lawrence College—and her new husband, Stanley Silverman. Stanley had just been commissioned to compose an opera for the Tanglewood festival and Mary suggested that we work together.

I had just done my first play, *Angelface*, at Jonas Mekas's Filmmaker's Cinematheque. I sent Stanley a copy of the script, not knowing what response to expect because—especially in the theatrical context of those days (1968)—my plays were *pretty* strange. Much to my surprise, Stanley wanted me to write his Tanglewood opera with him, so I drafted *Elephant Steps*.

Like many of my plays, the text was about a young man's initiation. The grotesque image of the elephant angels which dominated the piece came from my readings in Buddhist and Hindu mysticism, yoked to my interest in Brecht and German Expressionism. The first

third of the libretto consisted of abstract phrases, which Stanley treated atonally. In the remaining two thirds, his music delved into more popular traditions: Thirties swing, romantic ballads and rock and roll.

At that time the director Michael Kahn was my best friend in theatre—I had met him at New Dramatists, when I was a member of that playwrights' laboratory—and I suggested Michael as director, but he was busy that summer, so I suggested to Stanley that I could direct *Elephant Steps*. I had never directed anything except my little play at the Cinematheque, which everyone had thought was crazy, but Stanley considered my directing *Elephant Steps* a great idea.

Directing and designing at Tanglewood seemed like the big time to me. The production was Michael Tilson Thomas's first conducting job and it was the first time I'd ever worked with professionals. It was quite successful, very well received. In fact, Paul Simon, the singer-songwriter, who had been taking guitar lessons from Stanley, wanted to produce it commercially.

"Richard," Paul Simon said to me, "if all your dreams came true, what would happen with *Elephant Steps*?" Pretentious little me: I sat back in my chair and said, "There are three or four people in New York whose opinions I really respect. If those people liked it, that would be enough for me." Paul Simon lost interest immediately, and Stanley was understandably upset. If I'd said, "I think this could be as big as the Beatles," we probably would have had a major production on Broadway.

I loved the Rolling Stones in those days, so next I wrote a *very* aggressive pre-punk musical about young people, drugs and being beaten up by the police—I think it was called *Captain America*. It was full of aggressive sex. We showed it around to a few people who said, "Oh, well, we can't do this." Stanley had already set six or seven of the songs, so we collected those plus other songs he'd written, together with some songs from my early plays—about twenty songs total— and in 1971 I invented a scenario for them, *Dream Tantras for Western Massachusetts*. The great climactic number—one of the best stagings I ever did—was a huge long drug song, "Cocaine Dream."

The next year we did *Dr. Selavy's Magic Theatre*. Stanley had worked on a musical version of the *Satyricon* in Canada with the director John Hirsch. It was not a great success but everyone loved the songs, so I was approached to take those songs—with lyrics by Tom Hendry—to build another show around them. Inventing a scenario without any dialogue to bridge the gaps for the songs I had inherited, I found a way to *imply* a kind of action in *Dr. Selavy*. The result was our greatest popular success, but I *still* hear some people say that, while they loved it, many of their friends thought it was nonsensical trash. There was a lot of hostility towards it at the same time that it was widely appreciated.

Stefan Brecht responded enthusiastically, and he returned to see the show a second time with Art D'Lugoff, the owner of the Village Gate. Stefan was thinking of presenting *Threepenny Opera* at the Gate and wanted Art to use me as the director. That production fell through, but it eventually developed into the New York Shakespeare Festival production of *Threepenny*, which I directed for Joseph Papp at Lincoln Center. *Threepenny Opera* was the first work I directed which I hadn't written, the first time I worked with stars.

In a sense, that production closed a circle for me. I had read *The Threepenny Opera* in high school, in Eric Bentley's series *The Modern Theatre*, and I had written a letter to Lotte Lenya for a little summer theatre our high school drama coach had organized, asking for performance rights. Because we were in high school I had had to ask for permission to change the whores into Macheath's sisters. Lotte Lenya never responded.

When I think of music-theatre, I think of composers. To me, music-theatre *is* the composer.

When I was first working with Stanley, I knew he tended to have sweeter tastes than I. I liked aggressive, loud rock and roll, and that was not Stanley's real strength, which was for more lyrical, romantic music. I accepted that and tried to find a way to integrate it into my

system. Through the years, though, in various shows, I have written lyrics that demand a more lively, aggressive music than Stanley might have written left to his own choosing (not to say he didn't fulfill my choices brilliantly).

Our collaboration is quite loose. We certainly don't sit in a room together and work. I write the texts and mail them to him, and he asks me for a quick rundown of what I think the music should be at each moment. He either adheres to that or does something totally different. I haven't really written thinking, "Oh, this is for Stanley."

As the years have gone by, I've felt my texts have gotten Stanley's music into trouble. Generally, when our shows haven't gotten great reviews, it's my texts that have been attacked, not his music.

Hotel for Criminals (The American Imagination)

The idea for *Hotel for Criminals* came from a series of films shown at an early New York Film Festival—the early French serials devoted to the arch-criminal Fantomas, directed by Feuillade. At that time I was deeply in love with French culture and wanted to pretend I was in France. What better way than to create a show that took place there?

In the second half, though, the setting switched to America. The use of Stanley and myself as leading characters in that second half made me a bit self-conscious at the time, but now, with everybody doing one-person shows about themselves, I find it more acceptable, even rather charming.

I think of the first act of *Hotel for Criminals* like those exciting early moments in a film before you know how everything fits together. Everything seems to vibrate in ways that are both suggestive and provocative. The second act deepens into the profound confusion of nightmare, as French sensibility becomes lost within American innocence and primitivism.

Love & Science

Love & Science was written for Beverly Sills when she took over the New York City Opera. She was a friend of Stanley's—he had written a

song for her—and she asked him to do her first commission. It may have ended up being her *only* commission.

She wanted to open her first season with an evening of three one-act American operas. Stanley and I were quite happy with *Love & Science*, which we submitted, but Beverly said, "When the audience leaves New York City Opera, they have to know whether to laugh or to cry. This is too confusing. You want to do both at the same time." So I wrote a new libretto, which she produced, titled *Madame Adare*, and *Love & Science* had to wait until 1990 for its first production by the Music-Theatre Group.

Africanus Instructus

Originally, *Africanus Instructus* was a collection of pages that I looked upon as one of my straight plays. When I got the idea that it might make a musical, I completely rewrote it.

The new *Africanus Instructus* is obviously more accessible than in its nonmusical form. Using the same images and scenic ideas, I turned it into a sort of vaudeville show with a theme. I was influenced by my memories of attending reviews like *Lend an Ear* and *Call Me Mister*—to me, they seemed like a collection of highlights in which all the boring "between" of plot had been eliminated. That's the way one should approach my musicals: as musical revues structured like a theme and variations.

The theme in *Africanus Instructus* is the nineteenth- and twentieth-century obsession with bringing dark things to light. Exploring Africa was, for the white colonial imperialist societies, exploring the Dark Continent. Freud and Jung were exploring the dark unconscious, trying to bring *it* to light. That historical process has been the dominant preoccupation of so-called modern society, from the Industrial Age on. *Africanus Instructus* is essentially about having fun with that process, juggling the ideas and associations theatrically.

We were convinced *Africanus Instructus* would be well received. Instead it got terrible reviews, although they loved it when we took it on tour to Europe. I thought *Africanus Instructus* was perfectly clear, above-board and fun, but it's always hard for an artist to understand

why other people have problems with a piece. Since the artist lives inside of his material, it seems the most natural thing in the world to him. It's the air he breathes daily.

Yiddisher Teddy Bears

What interests me most in *Yiddisher Teddy Bears* is the individual song as a crossroads of colliding ideas and impulses. As I wrote it, I could see the show was developing both a symbolic and a specific, individualized narrative, but I never consciously planned that. Whatever shape the material ends up taking, I allow it to take that shape.

I thought *Yiddisher Teddy Bears* was accessible and touching, so I was surprised when initial readers took offense. One said, "This is anti-Semitic. Singing about 'schnozzle hooks' just isn't permissible in today's social context."

Then somebody who was sympathetic and wanted to work on it said, "I can see why people react negatively. After all, Richard, here you have these Jews exploiting Christmas by making teddy bears for the *goyim*. That paints the Jews as money-loving manipulators!"

But of course, within the play's context, I think that's a limited and erroneous reading. The Jews are obviously engaged in such an enterprise in response to circumstances far beyond their control. The particular teddy bear makers pictured here are not venal in any way that I, as a Jew myself, can imagine. In addition, I imagined the play as so surreal in its staging that it would be lifted to a level of "black comedy" that allows one to play with all manner of prejudices and stereotypes.

Last year on public television I saw a documentary about borscht-belt Jewish comedy in the Catskills during the Thirties. They showed onstage vignettes and—my God! were those Jews being anti-Semitic! Of course, you can say it was a very different time, with Jewish comedians performing for a specifically Jewish audience, but the way they played with language and inherited clichés about Jews was grotesque in a way that was funny, moving and liberating all at once.

Ours are difficult times, sensitive times, but to me this is a source of great theatrical energy. I don't think *Yiddisher Teddy Bears* is offen-

sive. I think it's affectionate and playful and, in fact, about the heroism of average, humanly fallible Jews.

I'm not blind to the fact that when one plays with inherited cultural clichés it may offend people. But when I wrote *Yiddisher Teddy Bears* I thought I was expressing love and affection for my own Jewishness. I've been trying to do that in more veiled forms for many years. *Yiddisher Teddy Bears* foregrounds it, but I can't help making fun of it (myself) at the same time.

I am a comic artist. The more people laugh, the better I like it. I'm happier the nights we get ten laughs instead of seven. If we get fifteen laughs, I'm even happier. I wish the audience were roaring with laughter throughout.

I think the plays I write for my own Ontological-Hysteric Theater are so densely packed, and things go by so quickly, that people are afraid that if they laugh they'll miss something. I have a reputation for being an intellectual, so a lot of people feel that laughing will trivialize the experience, but that isn't true. Of course the humor is off the wall, a little scary at the same time it's funny—unnerving, I hope, but funny.

For a long time I wanted to create works that had the structure of humor yet weren't necessarily funny. Many analyses of the structure of humor suggest that comedy consists of sudden jumps from the level of one logical type to another. Poetic jumps over such gaps are what interest me in art, so humor is relevant to my work whether or not a particular jump is funny. I think of myself as essentially a comic writer because I'm interested in the strategy of humor, in the same way that Freud relates humor to unconscious slips in which those unconscious slips can be manifestations of other concerns, on other levels.

That's the kind of laughter I'm after: laughter with deep roots in the frightening, in the unconscious, in the indefinable.

I enjoy doing musicals with popular-style music. In fact, that interests me more than doing *Wozzeck*, *Lulu* or other "serious" pieces that have aesthetic concerns which might seem closer to my own. I'd rather

combine the two—the tawdriness of popular music and popular theatrical ploys, and the darker, subterranean, Wagnerian forces that seem to come from the spiritual, archetypal world. I've always rejected purity in art. Even in my most austere moments I intercut lowdown "pop" elements. I like to put on Twenties jazz and have performers do goofy things amidst the most arcane philosophic impressionism. Finally, I think *Don Giovanni*, for instance, is more profound than *Tristan and Isolde*, because it is more multifaceted, less "singular" in its impulsiveness, in its openness to human self-contradiction.

I always want my theatrical manifestations, both my musicals and my regular plays, to sparkle with such multifacetedness. That is the word I think about when I work on them. I want the experience of seeing them to be like looking into the heart of a brightly lit crystal chandelier.

I happen to have a certain theatrical style, good or bad, that is somewhat different from what other people do. Attending my plays or musicals is like going to Kabuki theatre: The first thing you notice is the style. A lot of other things are there, but at first they seem obscured by that attention-grabbing style. Not everyone has the ability or desire to look more deeply into that flamboyant style to see the content embedded inside its twists and flourishes.

When Picasso painted a picture it came out one way, and when Matisse painted a picture it came out another, because style *is* the man. I have *my* style, but that style is used to say different things, in different ways, to different people. One of the reasons I was interested for many years in directing plays other than my own was that I felt my style was applicable and useful to all sorts of plays and musicals, to Molière, Büchner, Brecht-Weill, Mozart, etc. I think the style of my musicals is close to the style of my other plays, only the *content* is different, more accessible in the form of song and lyric exposition of an individual's emotional state.

. . .

I'm not driven to create musicals the way I'm driven to create my plays. An occasion will present itself: Somebody will telephone and say, "Wanna do a musical?" I'll say, "Why not?" But I haven't been thinking every day for the preceding year, "How can I take the next step in music-theatre, how can I *grow*?"

I think *Yiddisher Teddy Bears* might be the last of my librettos. I've always been more interested in doing my own plays, only now more so. The musicals have been fun, in the same way that directing classical plays has been fun, but I find myself less and less interested in taking such "vacations" from my Ontological-Hysteric work. It used to be exciting to handle all those people, with so many possibilities of complicated and spectacular effect, but as I get older that no longer seems interesting or gratifying. I have no more interest in the glamour of being a field commander in the exciting war of art. I prefer to work on a small scale, making intimate, dense theatre that finds music in other things than "music."

Aside from *Yiddisher Teddy Bears*, the only libretto still floating around that hasn't been staged and that I think somebody smart might someday decide to mount is an adaptation I made of Hawthorne's short story "Young Goodman Browne." I think the text is quite strong and offers a lot to a potential composer.

Other than that, I can't see writing any more musicals. Of course there have been many things in my life about which I've said, "I'm finished with this," and that hasn't been the case. If somebody decides to do *Yiddisher Teddy Bears* and it's a great success, admittedly it might renew my interest!

HOTEL
FOR
CRIMINALS

(THE AMERICAN
IMAGINATION)

Hotel for Criminals, written, designed and directed by Richard Foreman, with music by Stanley Silverman, was commissioned by the National Opera Foundation and presented by Lyn Austin and the Music-Theater Laboratory at the Lenox Art Center, Lenox, Massachusetts in August, 1974. A second production was presented by the Music Performance Group at the Exchange Theater, New York City in January, 1975.

CHARACTERS

Fantomas

Max

Helene

Irma Vep

Judex

M. Gaston

Alain Duchamp

Young Richard

Young Stanley

Old Richard

Old Stanley

Gang

Chorus

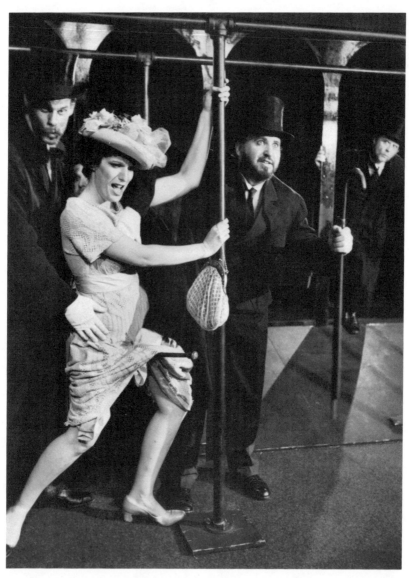

Paul Ukena, Lynn Gerb, Luther Enstad and Robert Schlee.

ACT 1

SCENE 1

VOICE: In the period just preceding the First World War, the French film maker Louis Feuillade created a number of film serials based upon certain novels, by Pierre Souvestre and Marcel Allain, which had obsessed the Parisian imagination in the few years preceding, recounting the exploits of mysterious, phantasmagoric Parisian criminals. These films placed in secret parts of the French imagination the faintly etched images of the black-hatted detective Judex, the vampiress Irma Vep, and the mysterious and elusive Fantomas.

Yes, yes, you heard me correctly. I spoke the name of the elusive *(Gong)* Fantomas.

How was that, you ask?

I said *(Gong)* Fantomas.

But what, you ask, is Fantomas? Who, you ask, is Fantomas?

Nobody, but somebody nevertheless.

And what, you ask, does this somebody do?

He frightens.

A series of small rooms, each with a curtained center arch. Fantomas revealed, newspaper in hand, against a wall.

FANTOMAS: Read the evening paper to relax. Look, look. My name across the page in a black headline . . .

Holds up the paper, headline reads "FANTOMAS!" Helene enters with his slippers

My daughter brings my slippers.

Blackout.

SCENE 2

VOICE: The young journalist, Max Beauchamp, held prisoner by Fantomas, perhaps. In love with the innocent Helene, daughter of Fantomas himself.

Another room. Max against the wall, his hands tied together. Helene enters.

MAX *(Turns his head away)*: I do not look at you.
HELENE: Have you ever seen me before?
MAX: No.
HELENE: Helene.
MAX: No. It isn't Helene.

They are both frozen as the music plays on.

Blackout.

SCENE 3

Max now in third room, still tied.

MAX:
FANTOMAS!
FANTOMAS! FANTOMAS!

PHANTOM CRIMINAL WHOSE DAUGHTER IS MY
 LOVE.
FANTOMAS!
FANTOMAS! FANTOMAS!
I TRY TO IMAGINE YOU BUT I DO NOT SUCCEED.
DO YOU HAVE A BODY OR ONLY A DAUGHTER?
DO YOU HAVE A SHAPE OR ONLY A SMILE?
HOW SHALL I PRETEND TO SPEND
THE TIME THAT I AM PRISONER?
OF COURSE, I'M NOT A PRISONER
BUT I PRETEND I AM.

Blackout.

SCENE 4

Max, Fantomas and Helene squeezed into a small room.

MAX: Thank you for paying my hotel bill.
FANTOMAS: I hope you've enjoyed your stay.

A door opens and M. Gaston crosses.

VOICE: The gentleman criminal, Monsieur Gaston, and his well-
 known whirling walk of terror.
MAX *(Pause)*: What kind of people stay here?
FANTOMAS: Criminals.
MAX: What?
FANTOMAS: Criminals.

Another door: Alain Duchamp crosses.

VOICE: The petite and insolent Alain Duchamp and his famous hop-
 step. Snapshot on the *Boulevard du Crime.*

MAX *(Pause)*: Where do you keep your disguises?

FANTOMAS: In the top drawer of the bureau.

Another door. The Criminals cross in line.

VOICE: Rarely seen, the notorious *Promenade des Criminels*, featuring in advance the delicate Julot l'Enjoleur, and, bringing up the rear, the notorious Dr. Lacloche, medical faculty, the Sorbonne . . . surgical division.

FANTOMAS *(Pause)*: Have a look if you like.

MAX: Will you untie my hands

FANTOMAS: Of course.

Music. No one moves.

MAX: You haven't untied them yet.

FANTOMAS: Will you marry my daughter?

MAX: That isn't your daughter.

FANTOMAS: Helene.

MAX: That isn't Helene.

Irma enters disguised as a chambermaid.

On second thought, maybe that is Helene.

FANTOMAS: I thought you'd realize your mistake.

Blackout.

SCENE 5

VOICE: What better way for Judex, friend of all victims, to secretly install himself at the side of the terrified Max? Yes, yes. Priestly vestments, since a marriage is being suggested.

Max, still tied; Fantomas; Helene, now in wedding veil. A priest, Judex in disguise, is untying Max. Irma enters, in

disguise as the chambermaid. They all turn to look at her and—freeze.

CHAMBERMAID: Excusez-moi.

She faints. Then Helene faints.

ALL:
EXCUSEZ-MOI.

MAX:
THE CHAMBERMAID WAS PRETTY
AND SHE CAME TO FIX MY ROOM.
I OFFERED HER ENTICEMENTS
AND SHE HIT ME WITH A BROOM.
SHE SHOWED ME WHAT SHE CARRIED
WHEN SHE OPENED UP HER FIST.
SHE PUT IT IN MY POCKET
SWORE SHE NEVER HAD BEEN KISSED.

SO I KISSED THE MAID
AND I BOUNCED HER ON MY KNEE
AND SHE ACTED BRAVE
AND RETURNED MY KISS TO ME
AND SHE SAID, "YOUNG MAN,
YOU ARE IN THE BRIDAL SUITE"
AND I KNEW RIGHT THEN
THAT I'D SWEPT HER OFF HER FEET.

SHE REAPPEARED AT LUNCHTIME
WITH A SANDWICH IN HER HAND
AND OPENED UP THE CLOSET
AND DEPOSITED SOME SAND.
THE SAND GOT IN THE SANDWICH
AND IT WASN'T NICE TO EAT.
WHEN I STARTED TO COMPLAIN SHE CAME
AND KICKED ME OFF MY SEAT.

SO I KISSED THE MAID
AND I BOUNCED HER ON MY KNEE
AND SHE ACTED BRAVE
AND RETURNED MY KISS TO ME
THEN SHE SAID, "YOUNG MAN,
YOU ARE IN THE BRIDAL SUITE"
AND I KNEW AT ONCE
THAT I'D SWEPT HER OFF HER FEET.

Blackout.

SCENE 6

Max, Fantomas, Priest (Judex), and Helene.

FANTOMAS: Would you like it if I put on one of my disguises?
MAX: Yes.

Fantomas dashes out.

JUDEX:
WHAT A BEAUTIFUL DAY FOR A WEDDING.
I KNEW IT WOULDN'T RAIN.
YOU CANNOT COMPLAIN—THE RAIN
HAS KINDLY STAYED AWAY.

Fantomas returns dressed as a nun.

FANTOMAS, JUDEX AND MAX:
WHAT A BEAUTIFUL DAY FOR A WEDDING.
THE FURNITURE IS OLD.
BUT DON'T COMPLAIN, THE DECOR
WON'T INTRUDE AT ALL.
FANTOMAS: Are you ready to marry her?
MAX: Yes.

JUDEX: Shhhhhhhhhhhhhhhhhh.
FANTOMAS AND MAX: Why that "Shhhh?"

Suddenly a huge, frightening bird is revealed in a door, posed.

ALL *(As they react in fear)*: Aughhhhhhhhhhhhhhhhhhhhh!
VOICE: What they see: an omen perhaps. A bird *(Gong—blackout)* of foreboding.

SCENE 7

Max alone. Leans back in his chair. A masked Irma enters in black tights and goes behind Max, places a handkerchief over his face and he falls unconscious. Then Irma takes his book. She leans against the wall and reads.

VOICE: She is reading the romance of her own story.

Fantomas and Helene, in the other room, listen through the wall.

FANTOMAS: Where is the second room? *(Pause)* Where is the second room that is really beautiful?
 (Pause) How do I find the second room, which is the room of adventure?
HELENE: Find it, Max. Find it, Max. Oh, find it, Max, my darling. Find it, find it, find it.
FANTOMAS: I have not found the second room, which is the room of adventure.

Blackout.

11

SCENE 8

VOICE: What you are about to see will cause you to reflect. Can such things happen, even in the dark back streets of Paris? Can such things be allowed to occur? Can such people be allowed to be what they are, do what they do, frighten whom they frighten?

Front of the hotel; night.

IRMA *(She stands in the hotel doorway, blocking the entrance with her body)*:
DO NOT . . .
DO NOT . . .
DO NOT ENTER . . .
DO NOT ENTER . . .
DO NOT SPEND THE EVENING INSIDE.
YOU MAY LOSE YOUR SOUL.
YOU MAY BECOME INVOLVED IN TERRIBLE THINGS.
IRMA AND MEN:
DO NOT ENTER.
DO NOT SPEND THE EVENING INSIDE.
YOU MAY LOSE YOUR SOUL.
YOU MAY BECOME INVOLVED IN TERRIBLE THINGS.
YOU MAY LOSE YOUR SOUL.
YOU MAY BECOME INVOLVED IN TERRIBLE THINGS.

Enter Max in doorway behind her. He cannot get through.

MAX: There's a lady blocking the door with her body.
IRMA:
IT'S MORNING, MORNING, MORNING, MORNING . . .
I'm afraid to leave the door. One hand on the right side of the door and one hand on the left side of the door.
MAX: Wasn't I supposed to be married to Helene last night?
IRMA: Can you see my face?

MAX: Did I marry her? *(Pause)* If I left the room, was it because I married her once?

MEN:

OH LADY, WHY ARE YOU SHAKING?

DO NOT ENTER . . . DO NOT ENTER . . .

IRMA: I need to be married also.

MAX: Can you see my face?

MEN:

DO NOT ENTER. DO NOT . . . ENTER.

IRMA: Yes.

MAX: Is there someone else in this hotel who looks like me?

IRMA: No.

MAX: Does he have the same name?

IRMA: Yes.

MAX: Why are you blocking the door with your body?

Now, Helene and Fantomas appear, and with Max, try to get out through the door, but Irma is blocking the door with her body; after a moment, straining and pushing and grunting, they give up and go back inside.

IRMA:

ISN'T IT AMAZING THAT A RELATIVELY SMALL

LITTLE LADY MADE THEM ALL GO BACK INSIDE?

LOOKING AT MY BODY YOU WOULD NOT

 ANTICIPATE

I COULD HOLD THEM AT THE DOOR ONCE HAVING

 TRIED.

BUT I TRIED, BUT I TRIED, BUT I TRIED, BUT I TRIED,

 BUT I TRIED

BUT I TRIED, BUT I TRIED.

BUT I TRIED, BUT I TRIED, BUT I TRIED, BUT I TRIED,

 BUT I TRIED

BUT I TRIED, BUT I TRIED, BUT I TRIED, BUT I TRIED,

 BUT I TRIED

BUT I TRIED, BUT I TRIED, BUT I TRIED.

Irma repeats song, joined by men.

Blackout.

SCENE 9

Lights up; Irma still blocking hotel door.

MEN:

LOOK, SHE'S STILL THERE.

Fantomas emerges, puts on dark glasses—exits, slow.

DOESN'T THE SUN BLIND YOU?
DOESN'T THE NIGHT EXHAUST YOU?
DOESN'T THE BODY FAIL YOU?
AND THE MIND
THE MIND
THE MIND
DOESN'T THE MIND FRIGHTEN YOU AFTER A
 WHILE?

As they sing, she is tied into her position at doorway. Helene enters clutching pocketbook. She stops with her legs apart, clutching pocketbook closer.

HELENE:

LADY, YOU DON'T FRIGHTEN ME.
I'VE SEEN YOUR KIND BEFORE
STANDING IN MY DOOR.
I LOOK THE OTHER WAY.

IRMA:

COULD I HAVE A GLASS OF WATER,

'CAUSE THE SUNLIGHT HURTS MY EYES?

HELENE:

LADY, I CAN TELL YOU CANNOT
DO ME ANY HARM.
YOU SHOULD GO AWAY.
I DO NOT CHOOSE TO PLAY.

MEN:

WON'T YOU PLAY WITH IRMA?
SHE'S ALONE AND LIKES THE SUN.
TRIES TO WARM HER BODY
BUT THE WARMING WON'T BE DONE.
DREAMS ABOUT THE CHILDREN WHO
ARE HAPPILY IN SCHOOL.
IRMA'S BEING PUNISHED
'CAUSE SHE'S BROKEN EVERY RULE.

IRMA:

COME AND PLAY.

HELENE:

GO AWAY.

IRMA:

CAN'T YOU SEE I'M ALONE?

HELENE:

I SHOULD BE SAFE AT HOME.

IRMA:

BUT YOU'RE HERE.

HELENE:

WE'RE ALONE

IRMA:

SET ME FREE.

HELENE:

I SHOULD BE WITH MY FATHER

Helene and Irma repeat song twice with men's chorus.

ALL:

SET ME FREE.

HELENE: But I'm frightened.

IRMA:

COME AND PLAY.

HELENE:

GO AWAY.

IRMA:

I'LL BE JUST BEHIND THE DOOR . . .
COULD I HAVE A GLASS OF WATER,
'CAUSE THE SUNLIGHT HURTS MY EYES.
IT REALLY DOES, REALLY DOES . . .

She repeats the last phrase until cut off by sound.

Horn.

Criminals put on masks as a silver Rolls Royce enters, driven by Fantomas, who is now masked. He rises in his seat and sings, as lights dim to evening and the moon glows in the sky.

FANTOMAS:

DON'T GO NEAR MY DAUGHTER
OR I'LL HIT YOU WITH MY CAR.
IT'S A SILVER-PLATED WEAPON
THAT I DRIVE BENEATH THE STARS.
WHEN THE MOON IS OVER PARIS
WITH MY DAUGHTER BY MY SIDE
I GO DREAMING THROUGH THE CITY
AND PRETEND THAT SHE'S MY BRIDE.

THOUGH SHE'S PROMISED TO ANOTHER
HE IS INNOCENT AND WEAK.
IN THE FACE OF MY ADVENTURES
HE'S AMAZED AND CANNOT SPEAK.
THOUGH MY DAUGHTER CLAIMS TO LOVE HIM
SHE IS INNOCENT AND PURE
AND I DO NOT MEAN TO SHOCK HER
SO IN SILENCE I ENDURE.

He continues as men's chorus sings "Ahh" in background.

AND I DO NOT SPEAK MY FEELINGS
BUT I PROMISE HER INSTEAD
TO THE COMFORT AND THE PASSION
OF ANOTHER PERSON'S BED
FANTOMAS AND MEN:
AND I FLOAT ACROSS THE CITY
LIKE A SHADOW BRINGING FEAR
AND THE BEAUTY I'VE IMAGINED
LEAVES A PAIN THAT BRINGS A TEAR.

Blackout.

Harsh lights up. Fantomas addresses the audience, with Criminals and Helene holding hands behind him, also facing audience.

FANTOMAS: Ladies and gentlemen, in just 25 seconds, after a slight readjustment in decor, we present Part Two of *Hotel For Criminals*.

Blackout.

SCENE 10

VOICE: Three A.M. The street is deserted. Max sits with his beloved and says to himself: "Do I recognize her? Do I know where I am?" A bird flies across the sky.

Night. Max and Helene sit at a cafe table. Bird slowly crosses rear, elegantly dressed.

MAX: Now the frightful bird is close to me. Now we can look at each other and compare each other's faces. Look, look, that is the face

of my fear. Look, look. Its ways are like the night. Look, look, it has no name but it has a body.

All enter halfway, frightened to expose themselves fully to the bird still poised there.

MAX: Look, look. All of the others are afraid. I am afraid too.

HELENE: Oh, Max, tell me there is nothing to fear.

Rimshot as Irma and Fantomas run on and pose.

HELENE: Why is that woman looking at me?

FANTOMAS: Which one is Helene? Why can't I tell which one is Helene?

MAX: Which one is Irma Vep, the temptress and criminal, and which, I repeat, which one is Helene, my beloved?

MEN:
ACCUSE, ACCUSE—ACCUSE, I ACCUSE.

JUDEX, MAX AND MEN'S CHORUS:
IRMA VEP THE HYPNOTIST
ACCUSE, I ACCUSE
IRMA VEP THE SORCERESS
ACCUSE, I ACCUSE
GENTLEMEN AND WOMEN
AND CHILDREN SOUND ASLEEP
FALL BENEATH YOUR POWERS
AND VANISH IN THE DEEP.

HELENE AND MEN:
IRMA VEP THE SORCERESS
ACCUSE, I ACCUSE
IRMA VEP THE VAMPIRESS
ACCUSE, I ACCUSE
DREAMING OF A MAIDEN
ABOUT TO BE A BRIDE
DREAMING OF HER FATHER

JUDEX:
FOREVER BY YOUR SIDE.

ALL:
>
> ACCUSE, I ACCUSE
> ACCUSE, I ACCUSE.

MAX, JUDEX AND MEN:
>
> GENTLEMEN AND WOMEN
> AND CHILDREN SOUND ASLEEP
> FALL BENEATH YOUR POWERS
> AND VANISH IN THE DEEP.

IRMA:
>
> IRMA VEP THE VAMPIRESS
> ACCUSE, I ACCUSE
> IRMA VEP IN FOULEDNESS
> ACCUSE, I ACCUSE

IRMA AND MEN:
>
> ENTERING THE BODY
> AND DRINKING OF THE PURE
> SPIRIT OF THE MAIDEN

JUDEX:
>
> THE HORROR AS THE CURE!

SCENE 11

All gather as if for a photo. A sign above reads "Paris 1913."

VOICE: Evil. Depravity. But another perspective exists. Behind closed doors the monstrous ones without the protection of the night. An insight: their private inertia. No past, no future, no memory, no anticipation.

MAX:
>
> THE GENTLEMAN SITS STARING
> THOUGH HIS EYES ARE ON THE MOON.
> THE MORNING SUN IS SHINING
> AND IT MAKES HIS DAUGHTER SWOON.

THE LADY IN THE ERMINE COAT
SAYS "RUB YOUR DAUGHTER'S BACK.
I'D LIKE TO MAKE HER HAPPY BUT
I HAVEN'T GOT THE KNACK."

ALL:

OH, INTIMATE REFLECTIONS
IN AN INTIMATE HOTEL.
WE ALL HAVE DIFFERENT BAGGAGE
AND THE BELLBOY STARTS TO YELL.
THE ROOMS WITH DIFFERENT NUMBERS
ARE MYSTERIOUSLY MIXED.
THE PLUMBING WHISPERS SECRETS
AND IT'S LONGING TO BE FIXED.

MAX:

THE GENTLEMAN STARTS TALKING
TO THE PICTURES ON THE WALL.
THE TELEPHONE REFUSES
TO PARTICIPATE AT ALL.
THE LADY COUNTS HER FINGERS
AND BEGINS TO COUNT HER TOES.
THE DAUGHTER HIDES HER TEARDROPS
IN THE PETALS OF A ROSE.

ALL:

OH, INTIMATE REFLECTIONS
IN AN INTIMATE HOTEL.
WE ALL HAVE DIFFERENT DEMONS
AND WE HIDE THEM VERY WELL.
THE ROOMS WITH DIFFERENT NUMBERS
DIFFERENT SHADOWS ON THE WALL
THE DOORS HAVE MANY SECRETS
BUT THEY NEVER TELL THEM ALL.

M. GASTON:

THE ROOM IS LIKE A GARDEN WITH
THE FLOWERS ALL ABOUT.
THE LADY AND THE GENTLEMAN

RESIST THE URGE TO SHOUT.
THE DAUGHTER IS SURPRISED TO FIND
SHE'S SUDDENLY RELAXED
AND WATCHES WHILE THE LADY HAS
ANXIETY ATTACKS.

ALAIN DUCHAMP:

THE LADY IN THE CORNER
TRIES TO CLIMB INSIDE THE WALL.
HER FEET MAKE TINY SCRATCHES
WHICH IS NOT REFINED AT ALL.
THE MANAGEMENT GETS WORRIED:
WILL THE DAMAGE BE SEVERE?
THE WALL ITSELF IS SILENT
AND IT DOESN'T SHOW ITS FEAR.

ALL:

THE DAUGHTER LIKE AN ANGEL
SHE RECEIVES A PAIR OF WINGS
NOT REALLY LIKE AN ANGEL'S
BUT JUST IMITATION THINGS.
SHE SEEMS TO BE AN ANGEL
'CAUSE SURROUNDED BY A THRONG
OF CRIMINALS AND PHANTOMS—

A CROWD OF CRIMINALS—
A CROWD OF—

MAX:

PHANTOMS.
ESCAPE WITH ME TO AMERICA.

SCENE 12

VOICE: In comparison with the criminals and phantoms surrounding
her, Helene is as if an angelic being, who sees beauty no matter
which way she faces. She is mistaken, of course, and so some-
thing bad will happen to her . . . something bad will happen . . .
something bad . . . bad.

*Street. Cafe tables. Irma and Max are near a table. Helene
slowly edges across upstage.*

IRMA:
COULDN'T I PARTICIPATE IN SUCH BEAUTY? THE
BEAUTIFUL
HELENE, CAN YOU IMAGINE SUCH BEAUTY . . . ?
MAX:
SHE IS MINE, SHE IS—
IRMA:
MINE, SHE IS MINE, SHE IS MINE, SHE IS MINE, SHE IS
MINE,
SHE IS MINE, SHE IS MINE, SHE IS MINE, SHE IS MINE,
SHE IS
MINE, SHE IS MINE, SHE IS MINE, SHE IS MINE, SHE IS
MINE, SHE
IS MINE, SHE IS MINE, SHE IS MINE, SHE IS MINE, SHE
IS MINE.

*Irma puts her finger in glass and tips it, as table is lifted over
her.*

VOICE: Can you see what she does? She puts a finger in her aperitif
glass, tips it, and the liquor dribbles to the floor.
JUDEX:
OH, IRMA
NAUGHTY GIRL!
NOBODY CAN TAKE A

NAUGHTY GIRL.
NOBODY HAS TIME FOR A
NAUGHTY GIRL
SO YOU BETTER MEND YOUR WAYS.

OH, IRMA
WHAT YOU'VE DONE!
IRMA MADE A MESS THAT
ISN'T FUN.
IRMA PUT A FINGER—
WASN'T NICE!
SO SHE'D BETTER ACT POLITE.

Stage crew runs string from bottom of Irma's glass—her finger still in it—to back of Helene's head.

JUDEX:
BAD IRMA!
WHAT'S UP NOW?
SOMETHING YOU'VE BEEN PLANNING
TELL ME HOW
HOW YOU TURN A FAUX-PAS
INSIDE OUT.
IRMA'S GOT A NOTION NOW.

OH, IRMA
DON'T YOU DARE
THINK YOU'VE GOT AN ANGLE.
IT'S NOT FAIR!
HOW DO YOU RECOVER?
WHAT'S THE KNACK?
IRMA WITH A NEW ATTACK.

JUDEX AND MEN:
OH, IRMA
QUITE A TRICK!
EVERYBODY THINKING
YOU WERE LICKED

SUDDENLY RECOVERS
ONCE AGAIN.
IRMA WORKING OUT A PLAN.

IRMA:

MY FINGER
IN THE GLASS
SHOOTING LIKE AN ARROW
STRAIGHT AND FAST
ENTERING AN ANGEL
THROUGH THE BRAIN.
IRMA IN CONTROL AGAIN.

HELENE AND MEN:

FEELING IN THE BODY
LEFT TO RIGHT
LEAVING LIKE A HEADLIGHT
LINE OF SIGHT
COMING IN BEHIND ME
HIT THE BRAIN
ANGEL WITH A DREAM OF PAIN
OH
ANGEL WITH A DREAM OF PAIN
OH
ANGEL WITH A DREAM OF PAIN.

IRMA:

SWEET ANGEL
LOOKS O.K.
IRMA'S GOT AN ANGLE
SHE WON'T SAY
HOW SHE PULLS IT OFF BUT
RIGHT AWAY
IRMA'S IN CONTROL AGAIN.

JUDEX AND MEN:

OH, IRMA
QUITE A TRICK!
EVERYBODY THINKING

YOU WERE LICKED
SUDDENLY RECOVERS
ONCE AGAIN.
IRMA WORKING OUT A PLAN.

IRMA: Notice my finger, still inside the glass.

MAX: I don't want to turn my head.

IRMA: Does it run from my finger or does it run from the glass?

MAX: Irma, poor Irma—

OTHERS: Shhhhhhhhhh.

MAX: —your finger is bleeding.

OTHERS: Shhhhhhhhhh.

MAX: My God, my God, your finger is bleeding from the finger!

HELENE:

AHHHHHHHHHHH!

IRMA: The angel tries to break my eardrums, hmh!

Fantomas' silver Rolls, driven by himself, is slowly entering. His horn gives a loud honk.

HELENE:

AHHHHHHHHHHHH!

IRMA: That was my glass singing, not Helene.

Horn.

She turns her eyes in circles but the string goes into the back of her head like a thin fire.

HORN *(On stage)*: Honk!

A crash from the orchestra as the silver Rolls hits Helene gently and she falls down.

IRMA: What a shame, what a shame. Can someone replace that angelic person who was just accidentally struck by that silver car?

ALL: Shhhhhhhhhh.

MAX: I'm cold . . .

Waiter covers him with a blanket.

FANTOMAS: Don't tell me I've hit something.

A nondescript girl comes out of the crowd and replaces Helene, the string is re-attached to the new girl.

FANTOMAS: One thing I don't need is trouble with the police.
MAX: If only Helene—
ALL: Shhhhhhhhhh.
MAX: —had come with me to America when I asked her.

Blackout.

SCENE 13

The crowd has gone. Max, at table under his blanket, holds his head. Irma stands with her finger in the glass. Fantomas is in his car.

Car starting.

FANTOMAS: It won't start. *(Pushes car horn)* Out of my way! Out of my way!

Irma tips the glass with her finger. Passer-by takes string from glass, crosses to Max and holds it to his head. She looks out.

My silver Rolls won't start.

Blackout.

SCENE 14

Fantomas is in car. Max stands wrapped in blanket.
Fantomas slowly puts on mask.

MAX: It's so cold.

He faints. Blackout.

SCENE 15

VOICE: Do you know that a serious and bizarre accident has been reported? A daughter has been struck by an automobile. A beloved daughter. A pure, innocent daughter.

The lights have revealed Helene, inside the hotel, sitting in a chair, her head bandaged.

HELENE:
WHAT HAPPENED TO MY WINGS?
WHAT HAPPENED TO MY BEAUTIFUL WINGS?
O DARK CITY, WITH MY WINGS I MIGHT HAVE
 FLOWN ABOVE YOUR RIVERS,
OUT INTO, OUT INTO THE SUN.

Judex appears with a birdcage, a small bird inside.

JUDEX: Release the bird from the cage, if ever you need my help.

Cage is lifted off bird, which flies slowly across stage.

JUDEX:
I THOUGHT IT WOULD FLY TO FIND ME
BUT IT FLIES TO THE LARGE BIRDS INSTEAD.
YOU CAN SEE IT FLY OVER THE CITY

WITH THE LARGE BIRDS
TOWARD THE WEST.

He lifts her from the chair, and carries her out.

VOICE: Question: Who was hit by the silver car of Fantomas?

Blackout.

Your answer may not be the right answer.

Violin solo.

SCENE 16

Gangsters sit reading newspapers. Max crawls in on hands and knees, head bandaged.

MAX: I have been hit by a silver car. I have been hit by a silver car, help me off my knees.

Gangsters laugh softly. A chambermaid enters behind Max with a sheet.

Help me off my knees so that I may search for Helene.

The chambermaid covers him with the sheet and exits. Gangsters laugh softly. Max sings under sheet.

JUST BECAUSE I'M DAMAGED
THERE'S NO NEED TO COVER ME
WITH A SHEET. I CANNOT SEE
AND THAT'S A DISADVANTAGE

JUST BECAUSE I'M DIZZY
AND I DON'T KNOW WHERE I AM.
I'LL RECOVER IF I CAN
BEGIN TO GET MY BEARINGS.

*At the rear of the corridor—amazing sight! Fantomas
suddenly appears in his silver car!*

FANTOMAS: Here I come! Here I come!
SUR----PRISE!
SURPRISE! SURPRISE!
I'M IN MY CAR.
HAVE YOU EVER SEEN A CAR IN A HOTEL?
IT WORKS PRETTY WELL.
NOT MUCH ROOM TO MANEUVER BUT
MY SILVER CAR IS DEAREST TO ME NOW.
MY DAUGHTER TAKEN FROM MY SIDE SOMEHOW.
I KEEP MY CAR BENEATH ME WHERE I GO.
ITS SILVER MUSCLES CALM MY FEARS AND SO
MY SILVER CAR ACCOMPANIES ME TO BED
AND DRIVES ME THROUGH THE DREAMS INSIDE MY
 HEAD
ITS COLOR LIKE THE MAGIC OF THE MOON
A SILVER BRIDE BENEATH A BURNING GROOM
WHO FLOATS ACROSS THE CITY'S SILHOUETTE
AND HAS NOT SEIZED ITS SILVER TREASURES YET.
OH SILVER CAR, I SLEEP BEHIND YOUR WHEEL.
OH SILVER CAR, MY SILVER DREAM-MOBILE.

*Max is slowly moving across the corridor under his sheet,
trying to get out of harm's way.*

FANTOMAS: What, what? We are not alone?
MAX: He's seen me, but he will not hit me.
FANTOMAS: Why not?
MAX:
 BECAUSE I'M ALL IN WHITE.
 WHITE IS PROTECTION.
FANTOMAS:
 —IN THAT DIRECTION
 A GHOSTLY PRESENCE FILLS MY HEART WITH PAIN.

I WILL ERASE IT
AT LEAST DEFACE IT
MY SILVER CAR
THE INSTRUMENT OF FATE.

FANTOMAS, MAX AND MEN:

OH, SILVER CAR OF FANTOMAS
RUN WILD WITHIN THE HALL
AMAZING SUCH A GIANT CAR
MANEUVERS HERE AT ALL.
OUTSIDE ALONG THE BOULEVARDS
OF PARIS QUITE A THREAT
BUT WHO'D HAVE DREAMED IN THIS HOTEL
THAT CAR COULD EVER GET!

FANTOMAS AND MEN:

HA-HA, HA-HA, HA-HA-HA-HA *(Etc. ad lib)*

FANTOMAS:

MAKE WAY, MAKE WAY, MAKE WAY, MAKE WAY,
AWAY!

MAX:

NO, NO! GO 'WAY
AND TAKE YOUR SILVER CAR AWAY!

CHORUS:

NO! NO! GO! GO! NO! NO! GO! GO!

Fantomas, Max and men repeat—OH, SILVER CAR OF
FANTOMAS, *etc.*

MAX AND FANTOMAS:

OH, SILVER CAR OF FANTOMAS
DOES NOT THE MEANING KNOW
OF MERCY TOWARD AN INNOCENT
AS PURE AS DRIVEN SNOW.
THE SILVER CAR SAYS, "HERE I COME,
DEFEAT ME IF YOU CAN!"
I SOUND THE CRY OF BATTLE
AND I IMPLEMENT MY PLAN!

CHORUS:

> EN GARDE, OLÉ
> YOU'RE IN MY WAY
> DEFEND YOURSELF, YOUNG MAN
> OLÉ!
> OLÉ!
> OLÉ

Max has been hit by the silver car. He is now placed in a coffin. He wears a skull. Coffin on its side on sawhorses. We see him in it.

CHORUS:

> THE SILVER CAR SUCCEEDS WHERE OTHERS FAIL.
> TO TRY ESCAPE ITS POWER IS OF NO AVAIL.
> THE MESSAGE THAT IT CARRIES IS THE HEAVY ONE
> OF FEAR.
> WHEREVER YOU ARE HIDING WE MAY SUDDENLY
> APPEAR.

Chorus repeats twice and fades out during second repeat because as Fantomas unscrews radiator cap of car, poison gas is released. Fantomas wears a gas mask, while the others fall to the floor choking to death.

FANTOMAS:

> THE SILVER CAR SUCCEEDS WHERE OTHERS FAIL.
> TO TRY ESCAPE ITS POWER IS OF NO AVAIL.
> THE MESSAGE THAT IT CARRIES IS THE HEAVY ONE
> OF FEAR.
> WHEREVER YOU ARE HIDING WE MAY SUDDENLY
> APPEAR.

Lights fade out.

VOICE: Ladies and gentlemen. A prologue of ominous activity has run its course, and a world of shadows sinks into the oblivion of terrible dreams . . . no longer remembered. Does youth, inno-

cence, virtue, fly . . . fly from the city of dreams west to a new continent where the innocent Helene regaining as it were, her birthright, innocence, awakens after a brief intermission, and you will join her in an American paradise of your own imagining almost regained.

Blackout.

END OF ACT 1

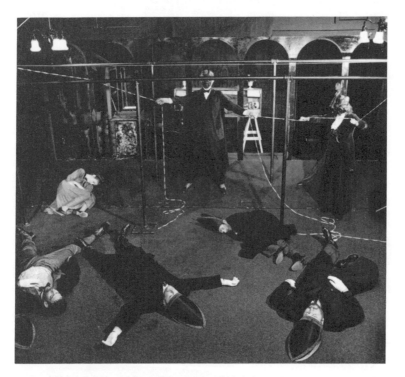

"The silver car succeeds where others fail.
To try escape its power is of no avail."

ACT 2

Lights up slowly. Helene, Young Richard, Young Stanley, and Judex are discovered. The boys sit in beach chairs outside of their boathouse. Judex and Helene play with a medicine ball in the black lake.

VOICE: Ladies and gentlemen. Ladies and gentlemen. The adventures that take place in America are adventures of the imagination.

Ladies and gentlemen. Ladies and gentlemen. The city of Paris is transformed by the American imagination into a forest. The imagination spreads through ancient cities of the old world like a virgin forest, casting shadows everywhere.

Ladies and gentlemen. The American sun rises, as Helene, French woman in a foreign land, life sustaining employment now hers: bringing into her careful charge two American children. Young, innocent, and so very, very impressionable.

SCENE 18

HELENE: A thunderstorm is going to come over the lake. What a strange feeling. Water under me and over me at the same time.

TWO BOYS:

 FRENCH LADY, FRENCH LADY
 GET OUT OF THE WATER
 THE THUNDER APPROACHING
 MIGHT DAMAGE YOU SO.

 FRENCH LADY, FRENCH LADY
 GET OUT OF THE WATER
 OUR MOTHERS HAVE WARNED US
 AND MOTHERS MUST KNOW.

 FRENCH LADY, FRENCH LADY
 THE SKY IS ABOVE YOU
 FRENCH LADY, FRENCH LADY
 THE FISH ARE BELOW.

 FRENCH LADY, FRENCH LADY
 WE'D LIKE TO BE WITH YOU
 FRENCH LADY, FRENCH LADY
 OUR MOTHERS SAY NO.

 DON'T GO
 SWIMMING THEY SAY
 WHEN THERE'S THUNDER IN THE AIR
 DON'T HIDE
 UNDER A TREE
 FOR THE LIGHTNING REACHES THERE.

 FRENCH LADY, FRENCH LADY
 YOU'VE TRAVELED THE OCEAN
 FRENCH LADY, FRENCH LADY
 YOU VISIT US NOW.

 FRENCH LADY, FRENCH LADY
 COME OUT OF THE WATER
 FRENCH LADY, FRENCH LADY
 WE'LL GIVE YOU A TOWEL.

YOUNG STANLEY *(Recit.)*: Oh French lady, who is that man on the roof of the other boathouse?

YOUNG RICHARD: I've seen him before.

YOUNG STANLEY: Is he a friend of yours?

YOUNG RICHARD: He looks peculiar too, like an Irishman or a Polishman or a French, French, Frenchman, maybe.

HELENE: Boys, little boys, what do you want of me? Boys, little boys. Tell me what you see when you look at me boys, little boys. Are you frightened of the water, do you always do the things you oughta . . .

BOYS:

FRENCH LADY, FRENCH LADY
YOU ACT SO PECULIAR
FRENCH LADY, FRENCH LADY
WE'RE VERY UPSET.

FRENCH LADY, FRENCH LADY
PLEASE TRY NOT TO SPOOK US
FRENCH LADY, FRENCH LADY
WE'D RATHER FORGET

FRENCH LADY, FRENCH LADY
THAT WE EVER MET YOU
FRENCH LADY, FRENCH LADY
A LOOK IN YOUR EYE.

FRENCH LADY, FRENCH LADY
COME OUT OF THE WATER
YOU'LL BE LESS DISTURBING
TO US IF YOU'RE DRY.

VOICE: To attract less attention to himself, French detective in a foreign land, Judex fishes nonchalantly into the black lake. But little boys imagine everything that happens and retreat into their childhood for a second time. Still afraid of the dark lake, dreaming into its depths, and the face of Helene reflected on its glassy surface is the face of a phantom.

The boys huddle together and sing softer.

BOYS:

FRENCH LADY, FRENCH LADY
THE WATER IS SHINING
FRENCH LADY, FRENCH LADY
THOUGH BLACKER THAN COAL
FRENCH LADY, FRENCH LADY
YOU LOOK LIKE A SPIRIT
FRENCH LADY, FRENCH LADY
THE LAKE HAS A HOLE.

Out of a black opening in the black lake's surface first comes a big frightening fish, and then following, as if each were swallowing the preceding one's tails, are Fantomas, Max, Irma, gang.

FRENCH LADY, FRENCH LADY
THE HOLE HAS NO BOTTOM
FRENCH LADY, FRENCH LADY
THE FISH THAT EMERGE
FRENCH LADY, FRENCH LADY
SAY WHERE DO THEY COME FROM
THE BOTTOMLESS HOLE
OF THE BOTTOMLESS URGE.

DON'T GO
SWIMMING UNTIL
LITTLE BOYS CAN KEEP AFLOAT

DREAM FISH
UP FROM THE DEEP
LITTLE BOYS CAN KEEP AFLOAT

DREAM FISH
UP FROM THE DEEP
LITTLE BOYS AFRAID TO SLEEP.

As they sing this last, they crouch together frightened.

SCENE 19

JUDEX: Oh Helene—my dearest, my love.

HELENE: No, no, in America I do not need your protection.

JUDEX: Are you certain? Look what comes out of the black lake of America.

HELENE: For shame, for shame—you naughty Frenchman, you frighten the little boys—

FANTOMAS, MAX, IRMA, ETC. *(Softly)*:
THROW US
THROW US BACK INTO THE LAKE.

On the opposite shore of the lake, the little amusement park lights up and the tiny ferris wheel and merry-go-round begin turning. The sky over the lake grows even darker.

FLOP, FLOP, WE SAY—

Singing more hysterical now.

FLOP, FLOP, FLOP FOR AIR!
THROW US BACK!
INTO THE BLACK HOLE!

VOICE: Question. Question: what pours out of the black American lake into the dreams of American children?

SCENE 20

CHORUS:
 BLACK LAKE
 BLACK LAKE
 BLACK BLACK
 LAKE OF AMERICA.

 BLACK LAKE
 BLACK LAKE
 BLACK BLACK
 LAKE OF AMERICA.

 HIDDEN HIDDEN
 LIKE THE FISH
 UNDERNEATH THE WATER.
 SLEEP SLEEP
 LIKE THE MICE
 UNDERNEATH THE BED.

BLACK LAKE
BLACK LAKE
DREAM DREAM
DREAM IN AMERICA.

 HIDDEN HIDDEN
 IN THE CHILD
 DEEP INSIDE THE MEMORY.
 SLEEP SLEEP
 LIKE THE LAND
 UNDERNEATH THE SUN.

WHITE SKY
WHITE SKY
WHITE WHITE
SKY OF AMERICA.

LOST LOST
IN THE TOWNS
ALL ACROSS AMERICA.
SLEEP SLEEP
LIKE THE SUN
BURNING LIKE THE MIND.

Blackout.

SCENE 21

Lights up. Young Richard is playing on the dock. Helene watches over him. Judex keeps her company.

VOICE: Oh, little Richard. Why doesn't your friend Stanley come and play with you?

YOUNG RICHARD *(On tape)*: I don't have a friend named Stanley. I live on this lake now, when I am a little boy, but I will not live here after I am thirteen years old. Stanley, on the contrary, does not live next to the black lake until he is thirty years old and a grown man. That is a historical fact. That is a historical fact.

HELENE *(She is studying a comic book)*: Would you like me to read you a story from this magazine?

YOUNG RICHARD: That's not a magazine, French lady.

HELENE: Oh, but it has nice pictures. And a story about bad, bad, criminals.

YOUNG RICHARD *(Points to Judex)*: Let him read it to me . . . let *him* read me about the criminals.

HELENE: Shhhhhhh! A little boy should know his place.

RICHARD: This is my place.

HELENE: A little boy should not talk to strangers, never to strangers.
DON'T TALK TO STRANGERS, 'CAUSE THEY MIGHT
FRIGHTEN YOU.

RICHARD:
I'M NEVER FRIGHTENED AND I GENERALLY DO.

JUDEX:
THE LADY'S RIGHT, YOU TAKE A TERRIBLE RISK.

RICHARD:
I'M JUST AFRAID OF OPPORTUNITIES MISSED.

ALL:
OH AMERICAN DARING, THE GET UP AND GO
OF AMERICAN YEARNING TO BE IN THE KNOW
A WORLD SO COMPLEX, DANGER ALWAYS AT HAND
BUT AMERICAN CHILDREN DO NOT UNDERSTAND
THAT THE ULTIMATE WEAPON
IS BEING DISCRETE
AND ACTING RESERVED WITH
THE PEOPLE YOU MEET.
'CAUSE THE WORLD HAS A GREAT MANY
TROUBLES IN STORE
FOR BRIGHT LITTLE BOYS
THAT THEIR MOTHERS ADORE.

HELENE:
DON'T BE SO QUICK TO THINK.
YOU'VE NOTHING TO FEAR.

RICHARD:
I THINK THE ONE THING TO FEAR MAY BE FEAR.

JUDEX:
DON'T COPY THINGS YOU'VE HEARD AND DON'T
UNDERSTAND.

RICHARD:
I THINK MY WORDS ARE PATRIOTIC AND GRAND.

HELENE:
I'M FROM A COUNTRY THAT'S MUCH OLDER AND
WISE.

RICHARD:
YOU'RE JUST CONFUSED A BIT BY AMERICAN SIZE.

JUDEX:
AH LITTLE BOY, YOU'RE BRINGING TEARS TO MY
EYES.

RICHARD:
A GOOD DETECTIVE NEVER BREAKS DOWN AND
CRIES.

ALL:
OH AMERICAN DARING, THE GET UP AND GO
OF PRIMITIVE YEARNINGS TO BE IN THE KNOW
THE WORLD SO COMPLEX, DANGER ALWAYS AT
HAND.

JUDEX/HELENE:
BUT AMERICAN CHILDREN, DO NOT UNDERSTAND
THAT THE ULTIMATE WEAPON MAY NEVER ARRIVE
AND LOSS IS THE PRICE PAID FOR BEING ALIVE.
THE ULTIMATE WISDOM
IS FEARING THE WORLD . . .
FEARING THE WORLD . . .
FEARING THE WORLD . . .

SCENE 22

YOUNG RICHARD: Do you have any children of your own, French
lady?

HELENE: No.

YOUNG RICHARD: Do you have a mother and father?

JUDEX: Shhhhhhhhh!

YOUNG RICHARD: Watch me. I'm going to jump into the lake still
dressed in my sailor's suit.

HELENE: Don't! Don't! Don't jump into the black lake—

YOUNG RICHARD: It's okay. I always do it.

Young Richard jumps into the lake, and Old Richard emerges.

VOICE: The child climbs into the black lake. But who rises from its waters twenty years later? The same child . . . twenty years later. The same dreams . . . twenty years later. The same longing.

OLD RICHARD: I see what is frightening, and I see what is beautiful. Look, look. Helene and Judex. Float, float away from me through the black water. Once before they vanish let me touch them.

VOICE: Does Richard kneel in the shallow water because he is frightened of them? No. No. He loves imagining their adventures. It gives him something interesting to write about. A memory . . . kneeling to memory.

Old Stanley enters with a ukulele.

The year: 1962. The scene: the shores of the black lake. The characters: Stanley and Richard, still innocent, but no longer children.

OLD STANLEY:
RICHARD, RICHARD
PLEASE GET OFF YOUR KNEES.
RICHARD, RICHARD
HEAR ME SINGING "PLEASE."
I CAN WRITE IT BETTER
FIT TO THE LETTER
 —IF YOUR BODY'S ON ITS FEET
 THE MELODY'S GONNA BE MORE COMPLETE.
SO RICHARD, RICHARD
PLEASE GET OFF YOUR KNEES.
RICHARD, RICHARD
MOVE YOURSELF AROUND.
RICHARD, RICHARD
PLEASE GET OFF THE GROUND.
I CAN GET EMOTION

IF YOU'D ADD SOME MOTION
 —IF YOU'D PUT SOME ACTION HERE
 THE AUDIENCE MIGHT BE MOVED TO CHEER.

SO RICHARD, RICHARD
PUT-A-LITTLE ACTION HERE.

HELENE/JUDEX: That sounds like American music.

As Old Stanley plays his ukulele, Fantomas enters behind him and puts a hood over Stanley's head.

VOICE: A certain American proves it. Proves he can play the ukulele with his head covered: under the waters of memory.

OLD RICHARD: It's because, it's because, it's because the light is so bright suddenly that he plays so beautifully.

OLD STANLEY: No. It's because I'm frightened.

OLD RICHARD: Of course. But what frightened you? One of us is dreaming in the lake, in the memory.

Gang enters and surrounds Old Stanley.

OLD STANLEY: And one of us is trying to make music, beautiful music, but he has been ravished by a gang of criminals. Criminals. Criminals!

OLD RICHARD: But which is more frightened, the ones whom the criminals are frightening, or the ones who are doing the frightening?

Richard and Stanley exit.

SCENE 23

CHORUS:

WE ARE LOST, LOST, LOST
IN THE DEPTHS OF AMERICA

WE ARE MEN, MEN, MEN
WHO APPEAR IN A DREAM
MEN IN NEED, NEED, NEED
OF A HOUSE IN AMERICA
IN THE BRIGHT, BRIGHT, SUN
WHEN THE DREAM IS SEEN.

Townspeople enter.

WE APPEAR, 'PEAR, 'PEAR
AT THE EDGE OF AMERICA
MEN OF FEAR, FEAR, FEAR
WHO ARE LOST AND ALONE
IN THE SUN, BRIGHT SUN
DISAPPEAR IN AMERICA
IN THE DREAM, DREAM, DREAM
THAT HAS NEVER BEGUN.

*Max and Irma enter, carrying suitcases. Fantomas drives
onstage in his car.*

SCENE 24

FANTOMAS:
SEARCHING FOR MY DAUGHTER AS
I GO AROUND THE WORLD
WILL I EVER FIND HER
WILL I REC-OG-NIZE HER
CAPTURING ACCOMPLICES
I FIND ALONG THE WAY
ADDING TO MY BAGGAGE
AS I RE-CONN-OITER
FINDING I'M FORGETTING WHAT

AT FIRST I SET ABOUT
ENTERTAINING DOUBT IN
SIDE THIS FOREIGN COUNT-RY
STOPPING BY THE ROADSIDE NOT—
CHORUS:
—COME JOIN US!
FANTOMAS:
—QUITE CERTAIN WHERE I AM—
CHORUS:
—THE WATER'S FINE.
FANTOMAS:
SUDDENLY CONFUSED, (WILL)—
CHORUS:
—A BATHING SUIT!
FANTOMAS:
—(WILL) I BE RECOGNIZED AGAIN.
CHORUS:
—IS WHAT YOU NEED!

SCENE 25

MAX: America. So vast in my imagining. So confusing to me as I set foot on its shores. Searching for my beloved, Helene. Somewhere amid a crowd of people just like these people. Will I be able to pick Helene out of a crowd of American people?
A CRIMINAL: Everybody into the water.
CHORUS: (Laughter, giggles, excitement)
MAX: Has anybody seen Helene?
A CRIMINAL: Everybody into the sun.

Judex approaches Fantomas, who wears his mask.

JUDEX: Don't you want your face to get the benefits of sunlight?

FANTOMAS: It's too bright.

Fantomas and Judex undress. Under their clothing they are wearing bathing suits.

VOICE: At last. Here in America, Judex, master detective, and Fantomas, master criminal, confront each other. But out of disguises. Both of them in bathing suits.

CHORUS:
(OH) YOU'VE GOT
NOTHING TO HIDE
IF THERE'S NOTHING INSIDE
IF YOUR HEAD IS EMPTY
CHOOSE THE SUN FOR YOUR FUN
IT'S O.K. TO BE DUMB
'CAUSE THE WATER'S COMFY.

(OH) YOU SHOULD
STRIP TO THE SKIN
SO YOU GET IN THE SWIM
WITH A PRETTY FILLY
BE AMERICAN-BRIGHT
'CAUSE THE MOMENT IS RIGHT
TO BE GAY AND SILLY.

MAKE YOUR SPLASH—FULL OF DASH
RAFFISH IN THE SHALLOW WATER
LIKE A FISH—PICK YOUR DISH—
(JUST MAKE SURE SHE AIN'T YOUR DAUGHTER . . .)

PRETTY CHICKS—TAKE YOUR PICK
SNATCH HER FROM THE ICY WATER
SNEAK A PECK, ON HER NECK
THAT'S THE WAY YOU OUGHTA COURT HER
(JUST MAKE SURE SHE'S NOT YOUR DAUGHTER . . .)

All exit except Young Stanley and Young Richard, Irma and Helene.

SCENE 26

HELENE *(Laughingly)*: Oh Irma, I think we have two small admirers.

IRMA: I think they're lovely—Let's . . . Not hurt their feelings.

STANLEY *(Pushing Richard)*: You go—

RICHARD: No you go—

STANLEY: No you go—

RICHARD: No you go—

IRMA/HELENE:

 BOYS . . . ?

 IS THERE SOMETHING YOU
 WANT
 TO
 ASK
 US?

RICHARD/STANLEY:

 YES . . . !

IRMA/HELENE:

 DON'T BE SHY COME A
 LONG
 AND
 ASK
 US

RICHARD/STANLEY:

 PLEASE . . . !

IRMA/HELENE:

 CAN'T IMAGINE WHAT
 YOU
 WOULD
 ASK
 US

RICHARD/STANLEY:

 WE . . . !

 BETTER ASK IT IN SONG.

—FRENCH LADIES . . .

HELENE: Oh Irma, I think we have two small admirers.

IRMA: I think they're lovely. Let's not hurt their feelings.

RICHARD/STANLEY:

WON'T
YOU
MARRY US LADIES?
WE HAVE TO WAIT FOR A COUPLE OF YEARS.
WON'T YOU
MARRY US LADIES?
WON'T YOU COME AND PLAY IN OUR HOUSE.

WON'T YOU
MARRY US LADIES?
WE HAVE TO PICK SO WE'LL EACH TAKE ONE BRIDE.
WON'T YOU
MARRY US LADIES?
WE'D HAVE LOTS OF FUN IF WE TRIED.

IRMA/HELENE:

BUT ARE YOU SURE—?

RICHARD/STANLEY:

—PLEASE, PLEASE
SAY YOU'LL MARRY US.

IRMA/HELENE:

WE'RE THE ONES—?

RICHARD/STANLEY:

PLEASE, PLEASE,
WE'LL HAVE LOTS OF FUN.

IRMA/HELENE:

WE'RE SO OLD—

RICHARD/STANLEY:

NO, NO—
YOU'RE SO BEAUTIFUL.

IRMA/HELENE:

. . . AND WE MIGHTN'T BE VERY MUCH,

MIGHTN'T BE VERY MUCH FUN!

RICHARD/STANLEY: —WE'D

 TEACH

 YOU . . .

HOW TO

PLAY WITH US LADIES

WE'D HAVE A LOT OF NICE CATS AND DOGGIES

THEY WOULD

PLAY WITH US LADIES

WON'T YOU TELL OUR MOMMAS IT'S DONE?

SCENE 27

Lights up on black lake where Max is discovered in a rowboat.

IRMA: Ah, look at Max. He's drifted out onto the lake . . .

MAX:

 HELENE—

IRMA:

 . . . ALL ALONE

HELENE:

 WE ARE STRANGERS HERE.

 WE ARE FRIGHTENED HERE.

YOUNG RICHARD/YOUNG STANLEY:

 OH, LADIES . . .

 YOUR FACES TURN TO STONE!

 YOU LEAVE US ALL ALONE!

The boys exit. Old Richard and Old Stanley enter.

OLD RICHARD/OLD STANLEY:

 CAN WE TOUCH YOUR FACES?

CAN WE TOUCH YOUR FACES?

MAX:

HELENE, MY HELENE!

IRMA:

OH, MAX, MAX, MAX. BE CAREFUL.

MAX:

HELP, HELP, HELP!

MY BOAT IS OVERTURNING!

OLD RICHARD/OLD STANLEY:

WE IMAGINE THE DISTANCE BETWEEN WHAT WE
 LOVE
AND WHAT WE IMAGINE.

CHORUS:

AH, HELP! POOR MAX!

HELENE:

MAX? MAX WHO?

MAX:

HELENE . . . HELENE . . . HELENE!

IRMA *(Crosses to telephone)*: Hello. Is this an American fire department? A Frenchman is drowning in one of your American lakes!

Judex and Fantomas in bathing suits jump into the black lake and swim towards the drowning Max.

JUDEX:

SAVE THAT MAN WHO'S DROWNING, HE'S IN
 TROUBLE FAR FROM SHORE
IF HE'S RESCUED THIS TIME HE WON'T ACT UP
 ANYMORE
SAD TO SAY THE LESSON'S OFTEN LEARNED WHEN
 IT'S TOO LATE
GOING DOWN IN WATER ALL ALONE, AN AWFUL
 FATE.

CHORUS:

HELP, HELP, HELP
ACROSS THE WATER: HEAR HIS DESPERATE PLEA

FAINTER NOW

AS IF AN OCEAN LIES BETWEEN YOU AND ME . . .

FANTOMAS:

MAYBE I'M INSPIRED 'CAUSE I'M IN THIS FOREIGN
LAND

TO EXTEND AN ENEMY A KIND OF HELPING HAND

I WILL TRY TO SAVE HIM THOUGH MY SWIMMING'S
NOT THE BEST

SAY IT'S FOR MY DAUGHTER THAT I TRY TO DO MY
BEST.

ALL:

GIANTS FROM ACROSS THE SEA ARE SWIMMING
THROUGH THE WAVES

ARMS ARE GETTING HEAVY, WILL THE SAVIORS BE
THE SAVED

BRAVE AND NOBLE FIGURES ALONE WITHIN THE
LAKE

IT MIGHT BE AN OCEAN RATHER THAN A TINY
LAKE.

CHORUS:

(TRAGEDY SO OFTEN SPRINGS FROM JUST A SMALL
MISTAKE)

TRAGEDY AND SORROW FROM A SINGLE SMALL
MISTAKE.

SCENE 28

Same. Quiet. Then the children Richard and Stanley enter.

RICHARD/STANLEY: Wake up. Wake up everybody. You're fooling
us. Stop playing games with us. Stop trying to trick us, we'll . . .
tickle you. Yes we'll tickle you. Yes we'll tickle you!!!

They start running from one to another, tickling, and soon everybody is laughing and rolling from side to side. They all laugh for a very long time as Richard and Stanley dance about and clap their hands with glee.

Then the lake opens in the center, and the silver car slides slowly from the center of the lake—Fantomas and Judex sit in the front seat. A strange blue light fills the whole stage and flickers.

CHORUS:
GET THAT CAR
OUT OF THE LAKE
FOR SHAME! FOR SHAME!
THAT'S GOING TOO FAR.

DEAD MEN!
DEAD MEN!
GET THAT CAR!
 OUT OF THE LAKE—

GET THAT CAR
OUT OF THE LAKE
IT CAN'T FLOAT
IT CAN'T FLOAT
FOR SHAME, FOR SHAME . . .

OLD RICHARD/OLD STANLEY:
FRIGHTEN ME. BE BEAUTIFUL.
AND FRIGHTEN ME AND BE BEAUTIFUL
AND FRIGHTEN ME AND BE BEAUTIFUL TO ME.

Helene and Irma have entered dressed as muses, each carrying a musical instrument—violin, lyre. They dance around Richard and Stanley. Penny arcade music plays. The amusement park lights up, as does marquee-type sign, THE AMERICAN IMAGINATION.

VOICE: Ladies and gentlemen. The American imagination. It's like

this. It devours everything from all parts of the world. Ladies and gentlemen. The American imagination. It's really like this. It's really like this.

All are silent. Large timpani roll.

Join us .. tonight, tomorrow night, and for weeks after, ladies and gentlemen, as we visit you again, and again, in dreams both pleasant, and the more interesting, and exciting

Rimshot.

unpleasant kind.

All begin long build of "Ohhh . . . " as lights fade out.

THE END

Lisa Kirchner and the Gang of Criminals.

LOVE & SCIENCE

Love & Science, written, designed and directed by Richard Foreman, with music by Stanley Silverman, was produced by the Music-Theater Group in association with the Ontological-Hysteric Theater and presented at Citizens Hall, Stockbridge, Massachusetts in July 1990 and at St. Clements, New York City in January and February, 1991.

CHARACTERS

Paul, a scientist (baritone)
Two Scientists (tenor and baritone)
Young Paul (boy soprano)

Elizabeth, Paul's wife (soprano)
Anna, a strange visitor (mezzo-soprano)
Marie, a scientist (soprano)

Two Bears, dancers (non-singing)

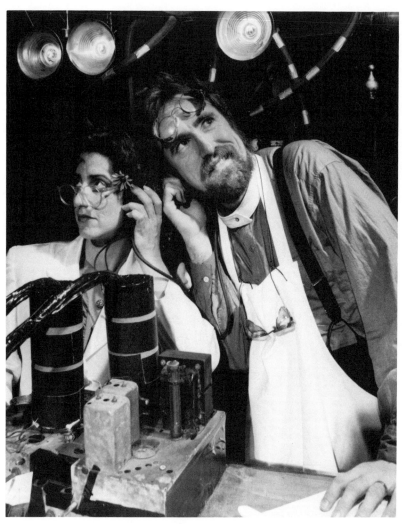

Nancy Bergman and Michael Willson.

Curtain up. Two radio towers, booths beneath. Two
Scientists, one of them Marie, in the booths.

SCIENTIST *(Rapid rhythm)*: MARIE *(Slower rhythm)*:
 Left, left, Right, right,
 Light, light Wood, wood
BOTH:
 Between, between!
SCIENTIST: MARIE:
 Left side Right side
 Listen Listen
 Listen Listen
 Light Wood
BOTH:
 Between, between!
SCIENTIST: MARIE:
 Listen! Listen!
 Footstep Footstep
 Listen Listen

Lights up center revealing the living room of Paul and
Elizabeth. Evening. Elizabeth poised, listening at center door.
She is frightened, but Anna, a mysterious lady-friend, calms
her.

Footstep Footstep
BOTH: Between! Between!

The Scientist and Marie rush off.

ELIZABETH *(Listening at the front door)*:
 I hear a foot
 a footstep

foot
approaching a door.
I hear a foot
on the floor!
Foot on the floor!
I hear a hand on the door.
I hear a left foot
right foot
left foot
right foot
left right, left right, left right!

She looks to Anna.

I hear a foot
approaching a door.
I hear a foot
on the floor.
I hear a floorboard
creaking, creaking
as if it were speaking
language concrete
language concrete
1, 2, 3, 4 letters
for every heartbeat.
Letters for every heartbeat.

Elizabeth turns away sadly as her husband Paul enters,
loaded down with papers. He is so preoccupied with his own
thoughts he doesn't even notice her.

My husband
always comes home to me
at the same
hour of the evening.
But sometimes
when he comes home to me

his mind is many
miles away.
His heart is
with his mind—
many miles away.

She turns to touch him gently.

Hello,
beloved Paul.

What did you invent today?
Using your mind,
what did you find?
What did you discover
using
your mind
today?

PAUL *(Looking at Anna)*:
Who is this strange visitor?
A friend of yours,
Elizabeth?

ELIZABETH:
Do you find the lady
beautiful
to your mind
or
is your mind
a hundred miles away?

PAUL:
I understand,
Elizabeth.
It makes you sad
when I am far away,
alone and at work
on my machines.

Listening!
Listening!
 That is how I do my work—
 listening!
Listening!
 to my wonderful machines—

ELIZABETH:

May I—
may I—
listen to your heart
beating in your chest?

PAUL:

Don't be absurd.

ELIZABETH:

What will I hear?

PAUL:

Absurd!

ELIZABETH:

A heart?

PAUL:

Absurd.

ELIZABETH:

A heart?

PAUL:

Don't forget our guest.

ELIZABETH:

Do I hear a
thump, thump, thump
coming from your heart?
Or do I hear a
thump, thump, thump
coming from your head?
Your head? Your head!

She and Anna by now are circling him, both limping.

PAUL:

Look how she walks.
Look how you walk!
Why are you lame,
Elizabeth?
You have never, never
walked like that before.

ELIZABETH:

Do you see something different
about me
dearest Paul?

PAUL:

I see you walk
the way this other woman walks.

ELIZABETH:

Ah, ah, you *do* see
something different?
See something different about my body?

PAUL *(Aria)*:

I've neglected you
Elizabeth,
because my work consumes me totally.
Certainly, certainly
I'm not an easy man
to share a life with.
Coming home tonight
I see strange things are happening
within my house.

Elizabeth and Anna trill behind.

But I accept all blame
because I haven't spent
the time with you
I should have spent—

My work consumes me,
yes,
consumes me totally.
The music that I hear
through my machines
consumes me totally.

Silence, then—

ELIZABETH:
Can you see
what's different . . .
tonight?

PAUL:
Everything is different.

ELIZABETH *(Triumphant)*:
Look at my shoe!
My shoe! My shoe!

PAUL:
What does a shoe mean?

ELIZABETH:
My new friend Anna—
who I did not know
until this afternoon,
when I was crying.

PAUL:
Why were you crying?

ELIZABETH:
My new friend Anna
came to my room.
But she was not alone.
Spirits were with her,
powerful spirits.

PAUL *(As Anna leads two trained Bears into the room)*:
No, not true.
That cannot be true.

ELIZABETH:
Powerful spirits
gave me
a shoe,
a shoe.
To wear on my right foot,
covering my right foot.

PAUL:
But why
a shoe?

ELIZABETH:
A shoe that was magic!
A magic
shoe.

She backs away.

Do you see
my magic shoe?

PAUL:
What does it do?
This so-called
magic shoe?

ELIZABETH *(Ecstatic)*:
My magic shoe,
my magic shoe.
See me wear my
magic shoe.
See me twist my
magic shoe.
Magic shoe.
Magic shoe.
Magic shoe!

PAUL *(Troubled, retreating. Overlaps her last repeats)*:
I'm thinking of a plan
my dearest

to repair the damage done here
when I leave you
lonely in this house
while I am working
miles away!
Miles away!
I will move my lab'ratory
with my great machines
to this house so we can be together
all the day
every day!
Then your magic shoe
will be no more use to you!

ELIZABETH:
No! No! No!

PAUL *(Overlaps her "no")*:
Then your magic shoe
will be no more use to you!

Calms her.

I don't believe in magic
and neither, my beloved,
should you.

ELIZABETH *(Ecstatically, as the Bears pose around her, echoed by Anna who sings "her" for "my" and "you" for "I")*:
It's on my right foot, Paul
and the right side
of my body
feels like light.
And the left side of my body
feels like wood.

But something moves between
from the one side
of my body

to the other side.
But I don't know
what it *is*.
But I don't know
what it's *called*.
Won't you name it
for me, beloved Paul?

PAUL *(Angrily)*:
Throw away your
magic shoe,
make this lady
vanish too.

ELIZABETH:
I will wear this
magic shoe,
which is what I
want to do.

PAUL:
Magic shoes are
in your mind.
Please believe me
when I find
all of this is
most disturbing
to a man of
 scien-tific learning.
This is what I name it,
"nonsense,"
total nonsense!

ELIZABETH:
No, you cannot
name it nonsense!

Quietly.

It makes the right side

of my body
feel like light.
It makes the left side
of my body
feel like wood.
But I know
there is something else . . .
between . . .

Transition: Paul's radio equipment fills the living room. He greets two visiting Scientists as Marie, a lady scientist, enters unnoticed behind them.

PAUL:

Kind gentlemen—
wise gentlemen—
let me explain
why I invite you to my home
instead of to my lab'ratory.
My wife has been alone too much,
and so I moved my work into my home.

SCIENTISTS:

We'd like to see a
demonstration
of your peculiar
radio station.

PAUL:

It's not a radio station, in fact,
but a kind of
radio receiver!
radio receiver!
radio receiver!

SCIENTIST:

But my dear Paul—
Paul, Paul, Paul.
We all have

radios
in our houses.
We listen to our
radios
in our houses,
every day.

The two laugh.

PAUL:

My radio is not
like other radios
but an invention of a special kind,
the only one
that you will ever find
approaching such a special kind
of radio!

My radio outshines all other radios.
Hear my sweet radio
inside the mind—
the hidden one a man can never find—
uncovered by a special kind of
radio!

For on this special kind
of radio, of radio, of radio,
you find
a special kind of music meant
for special ears—
not human ears
but other ears
than human ears!

Scientists back away.

No, no, gentlemen,
I am not insane!

My radio deserves the name
of something that allows a man to hear
a music meant for other ears
than human ears.

They gather. He puts earphones on one scientist.

Listen!
Listen!
SCIENTIST:
I hear nothing.
PAUL *(Quiet, smiles knowingly)*:
Impossible.
SCIENTIST:
I still
hear nothing.
PAUL *(Puts earphones on the second)*:
Listen carefully, please.
SCIENTIST TWO:
I hear nothing.
PAUL:
It's singing
just for you.
SCIENTIST TWO:
But I hear nothing, sir.
PAUL *(Earphones back on first)*:
Listen, listen very carefully.
SCIENTIST:
But nothing, sir,
is happening in my head.
PAUL *(Frowns, then angrily takes back the earphones, listens and
 explodes)*:
Why can't
they hear
the sounds that pierce my skull!
The music of the planets and the stars perhaps—

vibrations of great subtlety
are captured by my great machine
when to the deepest strata of the universe
I've tuned my radio,
my radio!
SCIENTISTS:
We hear nothing, sir!
PAUL:
Impossible!

Do you see my
two radio towers?
Alternating rapidly,
two becoming one.
I can hear it clearly!
And *you should too!*
And *you should too!*

Scientists laugh.

Don't laugh at me.
Don't laugh at me!
MARIE *(Steps forward in her white coat)*:
Forgive me, gentlemen, for interrupting . . .
May I listen?

Silence. Paul puts earphones on Marie.

MARIE *(Very soft)*:
Ahhhhhhhhh . . .
SCIENTISTS:
What does she say? What does she sing?
MARIE:
My body fills
with music from a place
I cannot find.

She turns to the two Scientists.

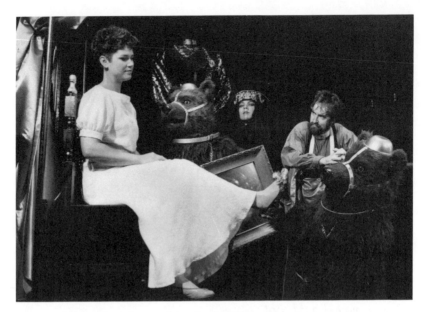

Teresa Eldh, Laila Salins and Michael Willson.

You gentlemen are
certain you did not hear
the music?

She turns back to Paul.

Be totally assured.
I hear it very clearly through my
left ear
and my
right ear.

*Music plays. Scientists exit. Only Marie remains, smiling at
Paul.*

PAUL:
Why do you imagine
aside from me
you're the only one to hear?

MARIE:

 I can hear it!
 I really hear it!
 Wonderful music . . .
 Such wonderful music . . .
 Ahhhhhhhhhhhhhh . . .

PAUL:

 Forgive me, if I ask you—
 to prove to me that what
 you claim is true—

MARIE:

 Of course, dear sir.

PAUL:

 Forgive me, but a scientist—

MARIE *(Has started to dance by herself and slowly comes to take his arm as he holds back, embarrassed)*:

 Of course, you are a great scientist.

PAUL:

 I'm so grateful to you, madam—

MARIE:

 Of course, of course.
 The animals hear it too.
 The dancing bears, of course,
 of course,
 are grateful just as I am!
 Oh inspired *wise man!*
 Oh my dear *complete man!*
 Oh my own *divine man!*

As she waxes ecstatic, Paul backs away confused. The Bears have frozen. Paul goes to the door and knocks.

PAUL *(Calls through)*:

 Elizabeth,
 see how

I have been justified,
come see
my triumphant hour—

MARIE:
Who do you call?

PAUL:
My Elizabeth!

MARIE:
Don't think of her,
or call to her—
come dance with me,
dance with me,
dance with me,
dance with me,
dance with me!
Ahhhhhhhhhhhh!

ELIZABETH & ANNA:
Ahhhhhhhhhhhh!

*Music builds. Marie and Bears dance, stamping frighteningly,
and Paul is swept into their dance.*

*Transition: Elizabeth looks into the room, sees the dancers
exit, whereupon she enters, dizzily, and leans against the side
wall. Anna comforts her.*

ELIZABETH:
You must give me
a second shoe.

ANNA:
One is the truth,
two are a lie.

ELIZABETH:
You must give me

a second shoe,
so I can dance with my husband.

ANNA:

One shoe is true,
but not two.

ELIZABETH:

I am so lonely—

ANNA:

Try to understand.
Half of your body
feels like gold, fire.
Half of your body
feels like wood, night.
What is between
two different feelings?
two different worlds
lives, dreams?
Try to feel something
growing between them, living between.
Love is between,
painful, lonely.
Love is between,
circling, circling.
Love is between.

ELIZABETH:

You must give me
a second shoe.

ANNA:

No, no,
no, no,
try to understand—

ELIZABETH:

I am so lonely
when I dream of dancing.

She takes a few awkward steps.

ANNA:

The body has a right side,
the body has a left side,
but they should never meet,
for love can only
circle in between,
circle in between!

ELIZABETH:

Please, please, please.

ANNA:

Try to understand—
love must have an emptiness
deep inside the body, that never can be whole—
try to understand
that love
travels in a circle
and the body is the emptiness inside.
And the body
is the circle
and the circle never meets—
and the heart beats
inside of emptiness
and the rhythm of the heart
beats between.
And all of life grows
where there is emptiness,
so never, never ask
to be complete.
Do not ask for
a second magic shoe.
Because one side
must be fire,
from which—a light is always shining,

and the other side
must be earth
from which—a tree is growing,
and the heart must circle
in between,
forever, forever in between.

Transition: back to the workshop. Paul and Marie both listen on earphones while Elizabeth hides in the shadows.

PAUL:
Do you hear
what I hear?

MARIE:
Of course!

PAUL:
Do you hear
what I hear now?

MARIE:
Of course!

PAUL:
What do you hear?

MARIE:
I hear what you hear, Paul,
the music you hear, Paul.

ELIZABETH *(In the shadows)*:
Paul, Paul . . .

Paul has taken off earphones and stares at Marie strangely.

I love you.
I love you Paul, I love you—

MARIE *(As if hypnotized)*:	ELIZABETH:
Paul, I love you.	Paul, I love you.
Paul Paul Paul, I love you.	Paul, I love you.
Paul Paul Paul, I love you.	Paul, I love you.
Paul Paul Paul, I love you.	Paul, I love you.

Aggressively.

I *love* you. Paul!

PAUL:
The singing that I hear is
coming from your heart and
not from my machines,
which means that you've pretended,
you've tricked me, deceived me.

MARIE *(Spoken)*: But it's you I love, not your radio.

A jazzy tune now.

PAUL:
Oh deceiving lady
what you've done to me!
Oh deceiving lady
having fun with me.

Making me believe in
what was
 never true.
Making me look foolish
must be
 fun, for you.

PAUL & SCIENTISTS:
Oh deceiving lady
what you've done to me!
Oh deceiving lady
having fun with me.

Making me believe in
what was
 never true.
Making me look foolish
must be
 fun, for you!

PAUL *(Break-rhythm solo, as men behind do scat back-up)*:
Now I—
bitter, but wise—
see the way the
world is fashioned.
You have
opened my eyes,
raised my hopes the
more to dash them.

SCIENTISTS:
Oh deceiving lady
what you've done to him.
Oh deceiving lady
having fun with him!

PAUL:
Making me believe in
what was
never true.

Making me look foolish
must be
fun, for you.

Making me look foolish
must be fun,
for you!

SCIENTISTS:
Bravo Paul, you
can't be blamed.
Devious woman
must have inflamed you.
Scientist of your great promise—
happened before and happens again—
devious woman misleading man.

Happened to us.

Happened to you.
Devious woman?
Nothing new.

Happened to us.
Happened to you.
Devious woman?
Nothing new!

PAUL:

Now, to purge my lab'ratory
and to purge my aching heart,
I'll give way to human passion:
smash the radio I've fashioned.

He prepares to smash his radio.

SCIENTISTS:

Bravo Paul,
the best solution.
Woman's touch has
caused pollution
of an idea, very grand,
sullied by a woman's hand.

PAUL:

I'll allow myself to do what I have never done,
conquering emotion is the battle I have always won.
Now I turn the tables on myself
and free my passion,
to smash the magic radio
that my giant brain has fashioned!

He tears the radio to pieces. The Bears cower in fear and all is quiet as Paul collapses in tears beside his destroyed radio. Elizabeth and Marie sing from the shadows.

ELIZABETH & MARIE *(Softly)*:

Look

what's on my right foot, Paul,
and the right side
of my body feels
like light,
and the left side
of my body feels
like wood . . .

PAUL:

What do I hear?

SCIENTISTS *(Peeking in at door)*:

We hear something too.

PAUL:

Impossible!
Impossible music—
my radio is broken.
And my towers,
my wonderful towers, cold and dark now.
What must I conclude?
Very hard to know.
Music's coming through,
but it can't be true!

He rises, bitterly.

What
I have
been
working on for
ten years,
totally destroyed.
But: I
hear the
very music that I heard from
my invention
which was
my two towers,

my two towers!

ELIZABETH & MARIE *(Softly)*:

My right side—

PAUL:

Why does it sound as if—?

ELIZABETH & MARIE:

My left side—

PAUL:

Impossible!

Paul as a young child is magically revealed, carrying a little radio in his arms.

ELIZABETH & MARIE:

The emptiness between—

PAUL:

But what I see—is impossible.
But what I see
is the lonely room where long ago a little boy
sits where he was sad and he was lonely.
And there, I see
a tiny radio
that years ago was mine
when I was lonely and alone.

Listening to
music
from my mind . . .

Lights brighten on Young Paul as he comes forward to smile at Paul, holding out his radio.

MARIE:

And something moves between
from one side of my body
to the other side—

But I don't know

what it is,
and I can't say
what it's called.
Won't you name it
for me, beloved Paul?

Paul reaches out for the tiny radio.

PAUL & YOUNG PAUL:
I can hear
the most beautiful music.
I can hear
the most wonderful music.

Now I hear it, now I hear . . .

And it fills
my whole body
and it enters through my heart.
And it fills
my tiny body
as I listen to the heart
singing deep inside my body
which is shining like a lamp,
which is beating like a drum.
PAUL:
Light
YOUNG PAUL:
Wood
PAUL:
Light
YOUNG PAUL:
A tree
PAUL:
A tree
and on
its branches

are shining birds that sing.

YOUNG PAUL:

That are shining like a drum.

PAUL:

That are pounding like the sun.

PAUL & YOUNG PAUL:

And the whole world I dream of
is multiplied again,
making so many worlds I reappear in,
and I'm different
in every one.

*Silence. Scientists rush in, searching about the dead machines.
Finding the battered radio, they sing.*

SCIENTISTS:

We were
right!—right?

We were
right!—right?

Nothing here
to hear! Here!

Nothing here
to upset our minds at all!

A moment's hold in silence.

We were right to have our doubts about the claims of
special music!
Nothing here to be discovered.
All is like we knew it had to be.
Nothing strange to be uncovered.
Life proceeds the way it has to be.
Rules are iron-clad and good.
Threats to reason's unity are

simply vile-ish, wild-ish, *childish, childish!*

ELIZABETH, MARIE & ANNA *(Striding forward through Scientists, scattering them)*:
They saw nothing—fools!
They heard nothing—fools!
They felt nothing—
they saw nothing—
Fools!
Fools!
Fools!

They imagined nothing different
but the world is always different,
but the world is always double
and the source of joy is trouble!
and the root of love is pain!
PAUL, YOUNG PAUL *(who both now wear gold crowns)* & CHORUS:
Contradiction is the force
keeps the universe on course!
Though the course is never straight
every obstacle is wondrous!
ELIZABETH & MARIE:
Every inner contradiction—
ANNA:
Is the secret benediction—
YOUNG PAUL *(Eyes shining)*:
Of a god both real and dead
who gives us all the many many
different things
that you can think of,
you can dream of
in your head
including
radio waves, of course,
and magic shoes, of course,

and magic bears
and scientific inventions
and beautiful ladies
and foolish men
and wise men
and foolish ladies
and hundreds and hundreds and hundreds of other things
I'm not old enough to know about,
but I know about them
 because I do,
and you know about them too,
 because you know everything
just like I do,
 you know everything
even if you don't know
 that you do
because I'm here to tell you
 that you really do.

Young Paul smiles knowingly at the audience as the others assemble behind him in awe and the lights slowly fade.

AFRICANUS INSTRUCTUS

Africanus Instructus, written, designed and directed by Richard Foreman, with music by Stanley Silverman, was presented by the Music-Theater Group/Lenox Art Center at St. Clements, New York City in January and February, 1986 and, subsequently, on tour in Europe.

CHARACTERS

Max
Otto
Ben
Black Max
Rhoda
Eleanor
Nurse
Headless Men, doubling as natives

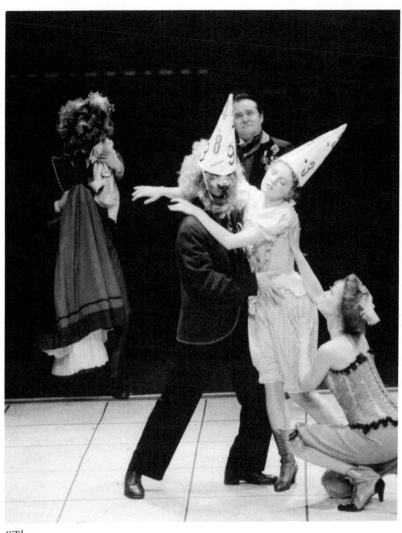

"*Then*
Her lily white arms in my full consciousness —
She puts them
Completely
Round the thick thick neck
Of the king, king, king of beasts,
Resplendent and glorious!"

OTTO: Two themes mixed together, ladies and gentlemen. What cards I hold, and what cards I don't hold. The world is vast, ladies and gentlemen. Have you visited the far reaches of the planet?

Sings.

THERE
> WHERE THE WORLD IS DIFFERENT FROM HERE,
> WHERE THE MOUNTAINS AND RIVERS
ARE DIFFERENT
> FROM THE MOUNTAINS AND RIVERS HERE . . .

Shuffle the cards of memory.

Music.

Then, give the combination a name. Slowly, as the lips open, and the breath flows, river-like—

ALL:
AFRICA!

OTTO: Shuffle the cards of memory. Ladies and gentlemen, must we call this the present, or must we think of this as the past!

Lays cards.

One. Eight. Nine. Seven.

RHODA: Yes! Eighteen ninety-seven. The year of my voyage to the interior.

MAX: Are you speaking in the past or the present?

RHODA *(Pause)*: . . . In the name of the present.

MAX: In fact—

RHODA: —speaking in the past.

MAX: Present—

RHODA: Dear friend—I'm looking into the difference.

MAX: Dear friend—looking into a mirror.

OTTO: Two themes are mixed, ladies and gentlemen. The present. The past.

All forward with cards.

ELEANOR: For example, the year 1897?

BEN: For example, the exoticism of exploration.

BLACK MAX: The dark continent versus—

NURSE: For instance, the black man versus his mirror image—

BLACK MAX: Of course.

Music. Masks.

OTTO: Ladies and gentlemen, how superficial are the following disguises?

Table with mountains.

RHODA *(Takes off mask)*: I think the dark continent—is—this place.

Noise. Shift.

Home safe.

OTTO: No such place.

RHODA: Wrong. Not at home yet. *(Pause)* Wrong. At home permanently? How curious—it's the same thing.

Music starts.

BLACK MAX: Two themes are mixed together, ladies and gentlemen, by time and space. Would you have it otherwise?

OTTO: The hypothetical . . . exotic—

Rhoda and Eleanor carry tea.

BLACK MAX: The . . . in fact . . . conventional.

RHODA: A perilous moment. If I spill this tea, the black man will put me across his knee and give me a good spanking.

ELEANOR: A perilous moment. If I spill this tea, the white man will put me over his knee and give me a good spanking.

BLACK MAX & OTTO:
 LITTLE GIRL, LITTLE GIRL,
 HOPE-A-HOPE THAT SHE'LL BE NAUGHTY.
 LITTLE GIRL, LITTLE GIRL,
 'CAUSE THE LESSON MUST BE TAUGHT, HE
 WOULDN'T DARE, WOULDN'T DARE,
 PUT ON AIRS
 WHEN
 HE'S
 ALONE
 WITH
 LITTLE GIRL, LITTLE GIRL,
 DID YOU BRING MY FOOT A SLIPPER?
 LET ME HAVE A LITTLE SIP-A,
 LITTLE GIRL.

Girls on knees, holding tea, men with foot on them.

 LITTLE GIRL, LITTLE GIRL,
 LITTLE TASTY LITTLE SAVAGE.
 LITTLE GIRL, LITTLE GIRL,
 LITTLE FEMALE PIECE OF BAGGAGE.
ELEANOR: The day will come, I—seated.
RHODA: The other, on the floor, licking the carpet at my feet.
OTTO: Totally possible—but not—
BLACK MAX: —your humble servant!
RHODA: Who else then?
NURSE *(Arrives smoking)*: Simply that person who wishes to be so
 discovered, licking that veritable carpet.

 AHH, NOW I FEEL LIKE I'M HOME
 IN MY COZY-COZY AGAIN—

—warm, well protected against the elements.

Screen about her. Black Max tied to bar.

OTTO: All themes, characters, continents, inextricably mixed, ladies

and gentlemen. At the end of that process is it, "world, thank you?" Or is it, "world, give us back certain distinctions, categories, and relevant . . . hierarchies."

BEN: The interior darkness, ladies and gentlemen.

BLACK MAX:

—AFRICAAAAAA.

BEN *(Over)*: Pinpoint! The back side of the brain!

BLACK MAX *(Tied up)*:

I ONCE SAW A BIRD
IN A CAGE OF GOLD
AND THE BIRD WAS GOLD
AND THE CAGE WAS GOLD
AND THE BIRD'S EYE
WAS A BRIGHT EYE
AND THE BIRD'S WING
WAS A SONG
AND THE BIRD'S CAGE
WAS INVISIBLE
AND THE BIRD
DISAPPEARED.
BUT DEEP IN THE SKY
AN INVISIBLE CRY
CALLS MYSELF TO ME
AND AN EMPTY EYE
MAKES A MEMORY LIE
AS THE BIRD
AND THE SONG
FLY FREE
TOWARDS ME
THE BIRD AND THE SONG
FLY FREE.

Music continues. Model mountains out.

MAX *(To Rhoda)*: Ah yes, isolated here my dear—

RHODA: Just what I've been thinking about.

Electric chair in.

MAX: A voyage?

RHODA: Total yes, but no hearts of darkness, thank you.

Pause.

MAX: In the mountains of a certain dark continent—

Violin music starts.

RHODA: —if there were mountains, yes, I'd feel free. But these aren't real mountains.

MAX: By the same token my dear, are you entering the real jungle?

RHODA: Proof!

MAX: Here's proof.

RHODA: I'm so much bigger than the mountains.

NURSE *(Over tip of screen)*: That's as it should be my dear, because we're all here to see you and not the mountains.

All run to rear.

RHODA:
YOU CAN LOOK AT ME
BUT YOU WILL NOT SEE ME.
I WON'T ALLOW IT.
I WILL HIDE MYSELF
BEHIND THAT WOODEN DOOR.

OTHERS:
FOOLISH MAIDEN. FOOLISH MAIDEN.
NOTHING TO HIDE. NOWHERE TO HIDE!

OTTO: You cannot hide at the center all darkness of such a continent. Because we are now, this moment, in the very center of a certain dark continent which does or does not exist and so: proceeding, indeed, to the center of that said dark continent is indeed: not to be hidden from *us*, who are already, very much, *there*.

RHODA *(Behind door)*:
CAN YOU SEE THROUGH WOOD?

IF I BELIEVED YOU COULD—

Others creep out.

I'D BURN THE WOOD.
I'D BURN THE DOOR.
THE FIRE WOULD SPREAD,
WOULD BURN THE FLOOR.
THE WORLD AROUND:
I'D BURN IT DOWN.
THE PEOPLE TOO,
LIKE ME, LIKE YOU,
ON FIRE, ON FIRE, ON FIRE, ON FIRE . . .

Vaudeville music. Enter Max and Otto.

MAX & OTTO:
NEVER SING "FIRE" IN A CROWDED THEATRE
OR THE FIRE WILL TURN ON YOU.
FIREMEN ARE GONNA BE ANGRY TOO
SO LOOK LOOK LOOK
WHAT ANGRY FIREMEN DO.

Enter Firemen led by Nurse and Black Max.

NURSE:
PUTTING OUT FIRES
FAST AS WE CAN,
FIRE ALL FINISHED—
WHAT HAPPENS THEN?
NO MORE FIRE
ISN'T SO GOOD.
FIRE CAN BE MISUNDERSTOOD.
FOR A WORLD WITHOUT FIRE IS NOTHING TO
 LONG FOR
UNLESS YOU WOULD LIKE TO RETURN TO THE
 JUNGLE

WHERE SAVAGES LIVE IN A PRIMITIVE WAY, WITH
 THEIR
PRIMITIVE CUSTOMS WHICH DON'T INCLUDE FIRE.
FORGED ON THE HEARTHS OF OUR CIVILIZATION,
FIRE'S THE SOURCE OF OUR CULTURE AND NATIONS
 THAT
GIVE TO THE WORLD
ALL ITS VALUES AND TRUTH, NEED THE HEAT OF
 THE FIRE
TO BURN TO THE TRUTH WHICH IS WAITING TO
 SERVE US
LIKE WHITE-HEATED IRON WHICH BURNS ON THE
 SKIN—

OTTO: Problematic—an "A" burned into my forehead. The alphabetic system?

MAX: A "One" burned into my forehead. The system of cardinal numbers?

All to wall. One hisses "fire."

BEN: Don't be frightened, of course. Fire on all sides. It hurts, but after it hurts—

ELEANOR *(On couch, Manet style. Silence)*: I'm burning up.

Sheet off.

OTTO: A soothing salve, dear one?

All fan cards. Eleanor fans self.

NURSE: Impulsive behavior. Civilized occurrences tossed to the wind.

All but Eleanor run off. Rhoda in with microphone strapped to head.

ELEANOR: Who's the uncivilized person, dear one? Me? You? Or the lady about to pour deep dark secrets into the recently invented microphone?

Others in with head mikes.

RHODA: This is how we make a living, dear one.

"Little Girl" music starts.

We entertain you people!

BEN: Understand, ladies and gentlemen, an invention to turn things inside out, as it were.

BLACK MAX *(Jungle, with red telephone)*: Qualified as follows—the message is coming over an even more recent invention.

Shift.

MAX: Immaterial, my good sirs, since one message is like every other message.

Cut directly to—

RHODA:
STORY OF MY LIFE.

Natives sneaking around tent.

WHO'S TALKING.
EVERYBODY'S TALKING.
PRETEND YOU'RE TALKING.
STORY OF MY LIFE.
OH.

Phone bell. Rises.

I BETTER FIND OUT WHO'S ON THE OTHER END OF
 THE TELEPHONE.

Reaches out.

REMEMBER ME LIKE THIS.
HOW.
REACHING FOR MESSAGES.

Tent flap closes.

MAX *(To Black Max, who still holds phone)*: Sir, did you expect to hear me speaking?

OTTO: Sir, are you thinking—it's always the same meaning—

OTTO & MAX:
> BLACK MAN
> WHATEVER YOU SAY
> IT COMES OUT THE SAME
> AS IF A WHITE MAN
> WAS SAYING IT.

BLACK MAX: Well boss, I do believe I's on one end of dis here telephone.

MAX & OTTO:
> AFRICAAAAAA!

BLACK MAX: But I do believe the message proper is for you white gentlemen.

OTTO: Telephones are *black* generally.

MAX: Shh! White, black, red—the message is generally the same?

OTTO:
> RED TELEPHONE, RED TELEPHONE,
> TO ME THAT MEANS EMERGENCY,
> BUT TO ME
> EVERY MOMENT OF LIFE IS
> AN EMERGENCY.

MAX *(Talks over)*: —And yet, one moment of life is like another moment of life.

OTTO:
> RED TELEPHONE, RED TELEPHONE,
> TO ME THAT MEANS EMERGENCY,
> AND TO ME
> EVERY MOMENT OF LIFE IS
> AN EMERGENCY.

BLACK MAX:
> IT WAS AS IF
> A RED TELEPHONE
> CARRIED A BLACK MESSAGE.

IT WAS AS IF
A TELEPHONE
WAS A MOUNTAIN
I COULD NOT CLIMB
BUT A WHITE MAN
CLIMBED.
IT WAS AS IF
A WHITE MAN
WAS LIKE A BLACK MESSAGE.
AND AS IF
BLACK MESSAGES
HAVE POWER OVER BLACK MEN.
 IT WAS AS IF
 A WHITE MAN
 COULD CLIMB A
 MOUNTAIN,
 AS IF A
 WHITE MAN
 COULD CLIMB A MOUNTAIN
AND FROM THE TOP OF THAT MOUNTAIN
THE WHITE MAN
COULD FLY . . .

Rhoda in electric chair rises.

OTTO: An unfortunate message. Really.

MAX: We . . . poets: turn, in fact, black messages into white messages.

RHODA:
THE PEOPLE WHO THINK THEY KNOW ME DO NOT
 KNOW ME.
I AM THE BLACK WOMAN. MY OUTSIDE IS WHITE:
 TRUE.
WHITE. BUT MY OUTSIDE IS WHITE FOR ONE
 REASON ONLY:

TO HIDE AN INSIDE WHICH IS BLACK. I WILL PROVE
 IT
TO YOU. I WILL PROVE IT TO YOU.

She turns, sees Black Max, screams and faints. They carry
Rhoda to couch. Music intro.

OTTO: Ladies and gentlemen. I ask myself, does the blackness of
inside, encountering a specific blackness outside, bring the inside
blackness into the outside . . .

MAX: Poet that I am, of course—my favorite color.

BLACK MAX:

BLACK MAX, DON'T BE AFRAID OF HIM.
BLACK MAX, CHILDREN WHO PLAYED WITH HIM
FIND HIM GENTLE AND KIND,
JUST THE SORT TO CALM THE MIND.

MAX:

BLACK MAX, TURN INTO POETRY.
BLACK MAX, THOUGH HE DON'T KNOW IT HE
FILLS THE EMPTY MIND
WITH ROMANCE OF ANCIENT KIND.

MAX & BLACK MAX:

BLACK MAX, DEEP IN AFRICA.
DOCTOR, QUITE A MATCH FOR HER.
WHICH, WATCH, MAKE A SNATCH FOR HER
 MIND . . .

BLACK MAX:

BLACK MAX, DON'T BE AFRAID OF HIM.
BLACK MAX, LADIES WHO PLAYED WITH HIM
FIND HIM GENTLE AND KIND,
JUST THE SORT TO EASE THE MIND.

Black Max goes toward Rhoda, picks her up. Ben enters.

ALL:

BLACK MAX, DON'T BE AFRAID OF HIM.
BLACK MAX, CHILDREN WHO PLAYED WITH HIM

FIND HIM GENTLE AND KIND,
JUST THE SORT TO CALM THE MIND.

BLACK MAX, TURN INTO POETRY.
BLACK MAX, THOUGH HE DON'T KNOW IT HE
FILLS THE EMPTY MIND
WITH ROMANCE OF ANCIENT KIND.
BLACK MAX—

BEN & BLACK MAX *(With others, variously)*:
—DEEP IN AFRICA.
DOCTOR, QUITE A MATCH FOR HER.
WHICH, WATCH, MAKE A SNATCH FOR HER MIND.

ALL *(Variously)*:
DON'T BE AFRAID OF HIM.
BLACK MAX, LADIES WHO PLAYED WITH HIM
FIND HIM GENTLE AND KIND,
JUST THE SORT—

BLACK MAX:
—TO EASE THE MIND.

OTTO: Back, back, Black Max.

BLACK MAX: I do believe I can help the white lady.

NURSE: Gentlemen, white medicine has help in hand.

MAX: Black medicine seems to have taken matters into its own hands, madam.

RHODA: Oh, Mr. Black Max, my energy box has run down completely.

BLACK MAX: Hummm. I do believe that is a disease specific of a future era, Miss Rhoda.

RHODA: Have you a cure for that specific disease?

BLACK MAX: Not in the future, not in the past—

RHODA: And more specifically—

BLACK MAX: Entering, slowly, the entire delicate white body—

RHODA: Please, says a lady of the nineteenth century.

BLACK MAX: Are you confident, Miss Rhoda?

RHODA: Confident, if cured.

BLACK MAX: But of course, Miss Rhoda. I've been curing you all through our intimate conversation.

NURSE: Forgive me. Mr. Black Max errs.

OTTO: Eros?

MAX: Eros errs?

Black Max takes Rhoda into tent.

NURSE *(As Natives rip dress)*: Eros dear one . . . errs not.

MAX: Errs not?

OTTO *(Pause, touches her underwear)*: I had no idea there was black, madam, under the pure white?

NURSE *(Twists his hand away)*: And you sir?

OTTO: Problematic. I'm not confident.

NURSE *(Hand inside his clothes)*: More confident, or less confident?

OTTO:
GET YOUR FINGERS
OFF MY BODY,
BUDDY, I'VE HAD QUITE ENOUGH
WHITE MAN'S BURDEN,
I AM CERTAIN
BODY SICK OF BODY STUFF.

NURSE:
BODY MEANS TO
YOU A BURDEN.
I AGREE IT'S
ON MY BACK,
WEIGHING DOWN A
LADY'S SPIRIT,
BODY UNDER SEX ATTACK.

OTTO & NURSE:
FREE THE BODY
FROM THE FINGERS
FEELING FOR THE TENDER PARTS,
WHITE MAN WANTS TO FREE HIS SPIRIT
FROM HIS AWFUL BODY PARTS.

WHITE MAN DREAMS THE
TIME IS COMING
WHEN THE BODY
TURNS TO SOUL, SPIRIT BURNING
THROUGH THE BODY
FILLING UP EACH
BODY HOLE.

ALL:

WORLD OF WHITE I-
MAGINATION
FLYING TOWARD THE
MIND'S DELIGHT.
HORDES OF PEOPLE
RULED BY SPIRIT
FINAL MIND AND
BODY FIGHT.

BLOODY BATTLE
NOW I SEE IT, EARTH BENEATH A TIDE OF BLOOD.
BODY FINALLY
SUBJUGATED
AND THE EARTH
SUFFUSED WITH LOVE.

ELEANOR:

LOVE, A LADY
IN HER ARMOR
SHINING IN THE
MORNING SUN,
LOVE AS RULER
OF THE PLANET,
FLESH AND MUSCLE OVERCOME.

NURSE (As all move off):

ALL THE WORLD A
FIELD OF BRIGHTNESS,
MULTITUDE RE-

SOLVED IN ONE.
NOTHING INTER-
FERES WITH LOVING
PURE AND WHITE, A
WORLD OF SUN.
ONLY WHITE AND
ONLY BRIGHT AND
ONLY WHAT WE WANT TO SEE,
ALL THE WORLD
THE SAME AS WHAT
THE LIGHT
ALLOWS THE LIGHT TO BE.

Return to jungle.

MAX: Foul, foul jungle? Thought we'd never make it back to civilization.
OTTO: Body like lead, muscles like lead, throat dry like the damn damn desert, damnit!

Drinks.

MAX *(Pause)*: Old chap, you do understand . . . while the body—
OTTO: Bloody body!
MAX: While the bloody body sinks like garbage.
OTTO *(Mutters)*: . . . yes yes yes.
MAX: . . . the spirit, old chap . . . well . . . soars.

Nurse enters with paraphernalia.

NURSE: Ah gentlemen: here amongst these snakes and crocodiles.
MAX: Here for the same reasons, madam.
NURSE: First aid, physical therapy—
MAX *(Gestures)*: On my couch please—
NURSE: Your *specialty*, doctor?
MAX: Nothing to be alarmed about . . . lie down and . . . tell me secrets.

NURSE:

> THE WORLD
> IS CHANGING SO FAST.
> DOCTOR, DOCTOR,
> THE NINETEENTH CENTURY FALLS ON ME LIKE
>> LEAD.

OTTO:

> OUT IN THE JUNGLE
> WHERE DISCOVERY
> IS THE ONLY FORM OF
> RECOVERY.

NURSE:

> THE NINETEENTH CENTURY
> FALLS ON ME LIKE LEAD.

OTTO & MAX:

> JUNGLE OR CITY
> WHERE ARE WE NOW?
> MIND IN THE CITY
> BUT BODY SOMEHOW
> LOST IN THE JUNGLE
> WITH BEASTIES AND BLACKIES
> WHO SMILE AND KOW-TOW BUT
> WHO PROMISE ATTACK-IES—

NURSE:

> THE NINETEENTH CENTURY
> FALLS ON ME LIKE LEAD.

MAX *(Turns)*: Some refreshment, madam?

Pours water.

NURSE: Your hand, sir—

MAX: My hand?

NURSE *(Pause)*: —is trembling!

MAX *(Pause, laughs)*: I did think, the lady was about to suggest that somehow this hand, a faint intensification of pigmentation? Oh no!

He gets into tub.

NURSE: You realize, I wouldn't have said that even if I had thought that.

OTTO: Say it openly my dear—

NURSE: Bad taste, doctor.

MAX *(Angry)*: Spit out the facts, madam. Damn braces, full speed ahead!

NURSE: —A *civilized* . . . discretion, my poor friend.

MAX:

CIVILIZATION, CIVILIZATION,
THE REVELATION
OF CIVILIZATION
IS CLEAR, HERE.

Served by Black Servants.

THOUGH WE'RE DEEP IN THE JUNGLE
DARK
 WHERE THE JUNGLE ANIMALS
PARK
 JUNGLE, JUNGLE, JUNGLE CARS
 PARKED OUTSIDE OF JUNGLE BARS
 SERVING JUNGLE GIN AND WHISKEY
JUNGLE WHISKEY, WHERE COULD THIS BE?

 VISIONS, FEARS
 THIS COULD BE
 WHAT I'VE NEEDED
 MISSING KEY—

 TURN THE KEY
 IN THE LOCK
 OPEN JUNGLE
 DOOR AND KNOCK—

 KNOCKING KNOCKING
 IN THE HEAD

JUNGLE COUNT
THE JUNGLE DEAD!

ALL:

1! 2! 3! 4! 5! 6! 7! 8!
KNOCK KNOCK KNOCK—

OTTO:

WHO'S DEAD!

Reaching for radio.

Ah . . . the head . . . spins . . .

NURSE *(Feeling ill also. Deep breaths. Whirls clubs)*: But a firm will
. . . sir . . .

OTTO: —the moment, perhaps, to reestablish contact with
civilization.

RHODA *(Appears)*: Hoping the radio still works?

OTTO: It always works!

MAX: We poets are working on poems even when it doesn't look like
we're working on poems.

RHODA: Question. What kind of doctor is a poet?

Reaches to radio.

Three feet!

NURSE: Did someone knock?

OTTO: Three feet what?

RHODA: Three feet!

Stomps across, arms stretched to radio.

Three feet!

MAX: Diagnosis: often a question of poetic insight.

OTTO: —three feet from my radio?

RHODA: Three feet!

OTTO: Three feet from civilization.

Turn on Rhoda.

RHODA: Three feet!

MAX & OTTO *(As Rhoda dances)*:
> THREE FEET, TRY TO BEAT IT—
>
> THREE FEET, I'M DISCRETE IT
> COULDN'T BE CLOSER, ANYWAY
>
> JUST THREE FEET AWAY!
>
> THREE FEET, JUST AS CLOSE AS
> TURNING, RADIOS IS
> SPREADING CULTURE EVERYWHERE
> VOICES, ON THE AIR!

RHODA:
> LOOK AGAIN, LOOK AGAIN
> THREE FEET MEANS I GOT A YEN TO
> BE A JUNGLE LADY WHO
> ACTS LIKE JUNGLE NATIVES DO!

CHORUS:
> THREE FEET, THREE FEET
> DID WE HEAR THAT THREE BEAT?
> TAKE A FOOT
> DO IT TWICE
> ADD ONE MORE TO
> MAKE IT NICE!

RHODA:
> FOOT CAN POINT TO RADIO STATION
> FILLING US WITH INFORMATION!

CHORUS:
> POINT US TO THE RADIO
> LET US KNOW HOW FAR TO GO
> USE YOUR FOOT
> HELPS YOU LISTEN
> FIND OUT WHAT YOU'RE REALLY MISSIN'
> HEARD HER RUN AND HEARD HER WALK
> NOW WE'D LIKE TO HEAR HER TALK!

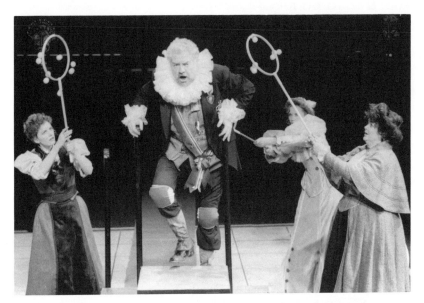

Eve Bennett-Gordon, David Sabin, Kate Dezina and Susan Browning.

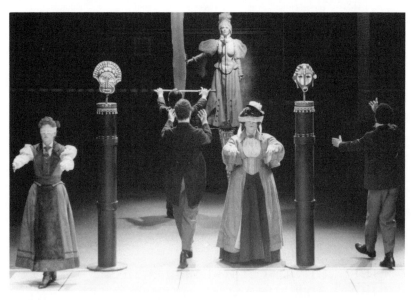

"The choice is yours, my dear."

RHODA:
WHEN I TALK, LOTS TO SAY
THREE FEET TAKES MY BREATH AWAY!
CHORUS:
WHAT YOU SAY JUST ISN'T TRUE
NO THREE FEET BUT ONLY TWO!
RHODA:
LOOK ME UP, LOOK ME DOWN
LOOK ME, LICK ME, ALL AROUND!
ONE ON THE LEFT
ONE ON THE RIGHT
ONE IN THE MIDDLE I SQUEEZE IN TIGHT!
BLACK MAX (Out of rhythm): Hummm, pardon my askin' but white
lady where *exactly* are you looking for me to stick this extra one
here, in the middle?
RHODA: Ain't you got the beat?
GET IT, GET IT
GET THE BEAT
GET THE BEAT
INTO THE MEAT!
BLACK MAX:
MEAT, MEAT
I GOT MEAT
SO I GOTTA
GET THE BEAT!
MAX & OTTO (As third leg is strapped to Rhoda and she dances):
THREE FEET
HUMAN GORILLA'S
FRESH MEAT
TRY TO INSTILL A
RESPECT FOR
CIVILIZATION IN
RED-BLOODED
HEAD-HUNTED
HUNTERS WHO

LOOK LIKE YOU!

MAX:

COME COME
BE A DISTURBING
NATIVE
INSTINCT UN-ERRING
BACK TO CIVILIZATION
DREAM OF
PACIFICATION!

OTTO:

TENT LIKE
HINT OF THE CITY
RADI-
O VERY PRETTY
BRINGING
NEWS OF THE CITY
PRETTY CITY
CIVIL, WITTY
PRETTY PRETTY
PRETTY PRETTY!

RHODA *(Clumping about)*:

THREE FEET, THREE FEET, I LIKE HAVING
THREE FEET!

ALL:

SWEET SWEET!

RHODA:

—I'M NOT SWEET! I PREFER MY THREE FEET!

ALL:

HELLO FEET
WHAT A BEAT!

RHODA:

HAVE YOU MET MY THREE FEET?

ALL:

FEET MEET
BEATING FEET!

RHODA:

 FEET ARE GOOD
 FOR BEATING MEAT!

ALL:

 RED WHITE BLACK MEAT
 EVERYTHING WE LIKE TO EAT
 THREE FEET THREE FEET
 CAN YOU HANDLE WHITE MEAT?

MAX, OTTO, NURSE & ELEANOR:

 BIG FEET FAT FEET
 DIFF'RENT KINDS OF FEET MEET!

RHODA:

 HELLO FEET
 HERE'S A TREAT
 GET INTO THE FEET BEAT
 I REPEAT
 WITH MY FEET
 EV'RY KINDA FOOT FEAT!

BEN: A profound interest in the lady's third leg. Does it in fact exist?

NURSE:

 AFRICAAAA!

BEN: Pay attention please! Twenty years in search of the exotic, the unbelievable: but *you*, madam. And your extraordinary appendage—my card. *(Thrown on floor)* Only one question. Are you a white person or a colored person?

RHODA: Perhaps a lady should respond to a collector of wild beasts not with an answer but with a surprise.

Open to lion.

BEN: Lions I have encountered my dear. My traveling organization is well-stocked with lions, tigers—

RHODA *(Leg up)*: In other words, the interest has not been lured away from this human appendage.

BEN: Shall we verify?

ALL: No!

BEN *(Chops off third leg)*: Ah, a surprise. My fascination runs its course.

OTTO: The masses rest indifferent to mundane reality and amuse themselves with the so-called exotic.

Music.

MAX: But as the world grows smaller, sir, and each distant culture delivers up artifacts—

BEN: Distant lands no longer hide real secrets, gentlemen.

MAX: One man's imagination, much like another man's imagination.

Rhoda has lion in headlock.

BEN: Hummm—piquant, in a way.

Music. As she pins him.

How to describe it. An ex-civilized, ex-three-footed lady of uncertain color. *(To Rhoda)* My dear madam. In an objective fashion, I have decided to involve myself in this . . . most original . . . manifestation.

OTTO *(Quietly)*: Magnificent, sir.

MAX: Bread and circuses sir.

BEN: On one condition.

RHODA: I expected one condition.

BEN: Would you try it . . . with *my* lion?

As new lion enters and Rhoda wrestles lion.

OH HO HO!
RHODA
WAS WRESTLING A LION
AND I'M IN
A QUAND'RY
SHOULD I DO IT TOO?

 'CAUSE EV-ER-Y HUMAN
 FIND DANGER, COME TRUE IN

THIS COUNTRY OF BEASTS WHO
WOULD CHEW ON
A HUMAN.

FOR MAN RULES THE WORLD
INSTEAD OF HIMSELF.
HE RARELY TAKES COURAGE
DOWN FROM THE SHELF.
IF HE WRESTLED LIONS
AT LEAST IF HE TRIED 'EM
HE MIGHT FIND THE LION
INSIDE OF HIMSELF.

ALL:

OH HO HO!
RHODA
WAS WRESTLING A LION
AND I'M IN
A QUAND'RY
SHOULD I DO IT TOO?
JUST A MERE LADY—

BEN:

—SHOULD SHE SAVE THE DAY FOR
THE HONOR OF MAN DO-
ING ALL THAT SHE CAN TO
SHOW BEASTIES, THOUGH STRONGER
HAVE NO SPECIAL CORNER
ON COURAGE OR VIGOR OR EVEN ELAN?
SHE'LL WRESTLE A LION
THOUGH I MAY BE CRYIN'
WHILE LION'S DECIDIN'
WILL HE WRESTLE MAN.

Many lions with many men.

You understand what I propose, ladies and gentlemen—man like
lion. Lion like woman. The ferocious struggle turned into a

dance, but—may we call it a dance? The implications are not happy.

Ladies and gentlemen, before our shared and inherited civilization sinks into final oblivion and exhaustion, before all political, social and cultural variety is melted down into the coming and expected multitude of sameness—

—before all circuses and may I say all bread besides vanish from our heavily laden tables—may I serve up for your delectation on my very specific *silver platter* designed to help you relish a very last meal—

Ladies and gentlemen, direct from the heart of the darkest dark continent available, wrenched from the jaws of approaching yet delayed illumination—

The effort! The awkward accomplishment. The ludicrous failures and false starts of species humanus, subcategory erectus—

Ladies and gentlemen, bleached, bloated, besotted, bedeviled *man*!

Curtain opens. Max crawls out of a volcano mound, down a red carpet on hands and knees to a downstage table. Then silver tray positioned against the back of his head at an angle.

MAX:
> HARD TO DO
> HARD TO DO
> THIS IS VERY
> HARD TO DO
>> WOULDN'T YOU
>> WOULDN'T YOU
>> LIKE TO DO IT TOO?
> I'M THE CENTER OF ATTENTION
> IN THIS WONDERFUL DIMENSION
> OF A WORLD OF PURE INVENTION

EVERYTHING I DO—
 HARD TO DO
 HARD TO DO
 VERY VERY
 HARD TO DO
NOTHING FALSE
NOTHING TRUE
 EVERYTHING IS
 DONE FOR YOU
GIVING PLEASURE
WITHOUT MEASURE
VERY VERY
HARD TO DO
HARD TO DO
HARD TO DO
VERY HARD TO DO!

BEN *(Leans close)*: Balance that please. Serving tray, against human head, being served.

MAX: Heads will roll, I've heard.

Foot on tray as it's reversed.

BEN: Alternative system. Heads imagining alternatives.

MAX: Am I reminded of an African precedent?

BEN: You were a certain kind of intellectual, *herr doktor.*

MAX: Correct. A certain kind of exploration did take place.

BEN: Specify the location?

MAX:
 AFRICAAAA!

Steak in on platter.

BLACK MAX: When you calls boss, I comes runnin'.

BEN *(To Black Max)*: And what degree of authentic accent am I now being offered, sir?

Black Max vocalizes as steak in, attached to Max's face.

MAX: Does this not evoke a certain core memory: category—sub-
continent. Listings: Africa, Africanus, Africanactic—

ALL:
> HARD TO DO
> HARD TO DO
> THIS IS VERY HARD TO DO
>> WOULDN'T YOU
>> WOULDN'T YOU
>> LIKE TO DO IT TOO?

WOMEN:
> I'M THE CENTER OF ATTENTION
> IN THIS WONDERFUL DIMENSION
> OF A WORLD OF PURE INVENTION
> EVERYTHING I DO—

ALL:
>> HARD TO DO
>> HARD TO DO
>> VERY VERY
>> HARD TO DO
> NOTHING FALSE
> NOTHING TRUE
>> EVERYTHING IS
>> DONE FOR YOU
> GIVING PLEASURE
> WITHOUT MEASURE
> VERY VERY
> HARD TO DO
> HARD TO DO
> HARD TO DO
> VERY HARD TO DO!

Pause.

BEN: Anything that we can do to make your reintroduction to civili-
zation more—

MAX: On my knees like this—

BLACK MAX: Humiliating to the white gentleman.

BEN: But of course, doctor. Which of us would not prefer to fly above all difficulty upon . . .

Music. Lift carpet edges.

. . . the desired magic carpet of the imagination?

MAX:
> IF A RUG COULD
> > FLOAT FLOAT FLOAT
>
> I'D BE ON A
> > BOAT BOAT BOAT
>
> SAILING TO
> > FOREIGN SHORES
> > FOR ADVENTURE
>
> BECALMED IN A
> > WORLD RUN DRY
>
> IMAGINING
> > HOW I'D TRY
>
> TO SAIL TO A
> > PLACE WHERE I
> > WOULD FIND ADVENTURE.

OTTO: Big fears, little fears, man in the middle fears.

BEN *(Into radio)*: It *is* the African explorer, it *is* the paleontologist, Lord Otto Sunk, deep in recreation of his famous journey astride the large semi-extinct dodo back-bucker, in veritable magic of flight!

OTTO:
> NIGHT FEARS, DAY FEARS
> KEEPING AT BAY FEARS

MAX:
> FLYING A BIRD
> MUCH LIKE A BIRD

EVERYONE'S HEARD
DANGEROUS BIRD!

OTTO & MAX:
FLY THROUGH THE NIGHT
OVER JUNGLE

MAX:
DESPITE

OTTO & MAX:
WAILING

MAX:
TO SKIES
WHERE THE GREAT BIRDS ON HIGH

OTTO & MAX:
CIRCLING, CIRCLING
WAITING TO SEE
EVERYTHING TERRIBLE HAPPENING TO ME.

OTTO:
I AM THE BIRD, OVER MY HEAD—

MAX:
I AM THE MAN, PRACTICALLY DEAD—

OTTO:
I AM THE BIRD, WAITING TO SEE—

OTTO & MAX:
DARKNESS DESCENDING, DEVOURING ME!

MAX *(Calling out over frantic activity and music)*: Don't do that . . .
my god, where are we going? Hold onto me, doctor. I will
explicate . . .

OTTO *(With thick German accent)*: Look at me, doctor, I'm *(Quiet now)* flipping . . . flapping . . . What? Am I think having trauma?
Am I acting in my own personal three-part with official prologue-
epilogue tragedy-drama which works good? Next patient. Please.

Flash. Picks up Rhoda, supported by Ben.

RHODA: My dream was frightening doctor. First you were flying, and

then you emerged from a kind of hole, perhaps. Or a volcano.
And then I thought—might I also—one day, perhaps, soon—
BEN: Keep talking, my dear.

Helps her on couch, sits behind.

RHODA: One thing you should know. I don't believe in . . . psycho—
psycho—

She twists to look.

MAX *(Shielding self)*: Don't look at me, please!
RHODA: Why—
MAX: You mustn't look at me!

He screams.

NURSE: Doctor Afreud?
RHODA *(Back on couch)*: Afraid?

Ben replaces Max.

BEN: Tell me everything you can possibly remember.

Flash to Max and Otto at table before tent.

MAX: Appearing in this miserable circus, of course, which I consider
an exploitation of my person and my profession—
OTTO: Your move, doctor.
MAX: You mean, the ball is in my court now?

A ball rolls in from tent. He laughs.

OTTO: Are you amused, doctor? Childlike? Innocent?
MAX *(Picks up ball)*:
ROUND, LIKE MY HEAD
ROUND, LIKE THE WORLD
ROUND, LIKE BEGINNINGS WHICH HAVE NO
BEGINNINGS

ROUND, LIKE MY LIFE

ROUND, LIKE ADVENTURES
ROUND, LIKE MY THINKING WHICH THINKS USING
 THINKING

WORLD, WORLD!

OTTO: Snap out of it, doctor!

Gold ball rolls by, picked up by Max.

MAX *(Pause)*: I'm caught, my friend.

OTTO: Bah. A momentary regression to childhood . . .

Flash. Second jungle. Two dance.

MAX: Yes, that's right. Yes, that's it. Exactly. I am no longer impressed with messages that link the banal to the equally banal.

OTTO *(Chuckles)*: I think we can restart the mental engine, eh?

MAX: Consider. Is there anything left to tweak the exhausted imagination of two weary, civilized gentlemen such as we had become?

OTTO: Speak for yourself sir.

MAX: Admit it! Sir—

OTTO: The young woman for instance? Wrestling the lion? *(Pause)* Piquant . . . rather . . . daring, eh?

MAX: It's permitted, dear friend.

OTTO: Damn kinky!

MAX: Each secret tendency, each private foray, rendered suddenly— innocuous!

OTTO *(Moans, staggers)*:
THE NINETEENTH CENTURY
FALLS ON ME
LIKE LEAD.

ALL:
FELL ON HIS HEAD
LIKE LEAD, LIKE LEAD.

Repeat three times.

RHODA: I've discovered something. An era in which, uniquely, all is permitted. I shall therefore immediately hurl myself into the seductive arms of my lion antagonist.

Eleanor in boxing gloves.

Oh?

ELEANOR: A certain public enjoys watching ladies tumble to the floor together, my dear.

RHODA *(Angry)*: Oh!

ELEANOR: Never say "oh."

RHODA: Something else comes to mind.

ELEANOR: Keep up with the times, my dear.

ALL:

OH!—

ELEANOR:

MUST GO FROM YOUR REPERTOIRE.
PICK IT UP,
THROW IT VERY FAR,
OH, LIKE DOUBT AND OTHER DAINTY SQUEALINGS,
THROW THEM OUT,
ALL YOUR FANCY FEELINGS.

NURSE:

YOU MUST CHOOSE WORDS A LITTLE
MEAN, BRAVE AND TOUGH,
JUST LIKE A MACHINE.
IN EACH WORD HAS TO BE A POWER
LIKE A FIST, NOT A DAINTY FLOWER.

RHODA: A machine? Like a machine?

NURSE: Like the world itself my dear, ruthless, to the point!

WORDS LIKE THE WORLD
WORDS LIKE THE WORLD
WORDS LIKE THE WORDS
LIKE THE MODERN WORLD!

RHODA: I have a different vision I fear, not soulless machines at the

center of each living thing but the mysterious energy that makes
things grow . . . oh!—

NURSE:

THERE ARE FIGHTING MACHINES AND DELIGHTING
 MACHINES,
BITING AND SPITTING UP-TIGHTING MACHINES,
AND MEANER MACHINES THAT TRY TO ACT NICE,
AND EVEN MACHINES GIVING FIRST-RATE ADVICE!

THERE ARE EATING MACHINES AND REPEATING
 MACHINES,
REDUCTO ABSTRUSELY RECITING MACHINES,
AND AFRICAN ABRACADABRA MACHINES
THAT GO AFTER BODIES WITH FORK AND WITH
 KNIFE!

MEN:

FEED A MACHINE, FEED A MACHINE,
NOTHING ELSE TO DO.
FEED A MACHINE, FEED A MACHINE,
YOU'LL GET HUNGRY TOO.

RHODA: I still maintain—

BEN: Please. Not another word concerning your famous investiga-
tions of African sensibility.

RHODA *(Pause)*: Of course. You're really more interested in seeing
me tussle with some additional members of the animal kingdom.

BEN: Exactly. Public tastes, my dear.

MAX: Without making any moral judgements as to your character,
sir—

BEN: My dear sir, what's permitted and what's not permitted happen
to be mere options of the given historical moment.

*Flourish. Two doors open. Eleanor in lion costume and Black
Max in lion costume. Drum roll.*

The world and its value systems are in flux doctor.

OTTO & MAX: Absolutely shocking!

BEN: First, she undresses for me right now so that more of her body can be easily called to mind.

Rhoda strips to costume.

THEN
HER LILY WHITE ARMS IN MY FULL
 CONSCIOUSNESS—
SHE PUTS THEM
COMPLETELY
ROUND THE THICK THICK NECK
OF THE KING, KING, KING OF BEASTS,
RESPLENDENT AND GLORIOUS!

MAX *(Nervously, puts on dark glasses as Black Max, Rhoda and Eleanor are all entwined)*:
WHEN THE WHITE MAN'S GOD IS DEAD, MY GOD,
EVERYTHING IS PERMITTED TO MAN.

Black Max, Rhoda and Eleanor writhing in each other's arms.

For your sake sir, I hope this won't bring you a few hours hence to find self-flagellation necessary or desirable—

BEN: Perhaps I should return to that jungle from which I ostensibly derive . . .

MAX: Haven't you noticed sir? No more jungle.

BEN: I see a jungle.

MAX: Where?

BEN:
THE NINETEENTH CENTURY
FALLS ON ME LIKE LEAD.

MAX: Living in the past, sir?

BEN: Impossible. That can't be my problem.

Wheel in tea.

MAX: Tea?

BEN: Would it be good for me?

MAX: May I take notes, while you talk between sips of tea?
BEN: A pencil doesn't frighten me.
 1 2 3 4 5 6 7
 ALL GOOD CHILDREN GO TO HEAVEN.
 USE YOUR FINGERS AND YOUR TOES.
 I RESPECT A MAN WHO KNOWS.
 CURE ME, CURE ME, FIX MY HEAD,
 SEND ME PACKING OFF TO BED.
 NOTHING GIVES ME SATISFACTION.
 NO ACHIEVEMENT WORTH THE ACTION.
 MODERN WORLD JUST CHEAP DISTRACTION
 PLEASING TO THE BOURGEOIS FACTION.
 ALL THE PEOPLE WHO SURROUND ME
 SHOOT MY SPIRITS DOWN AND HOUND ME
 WITH THEIR PETTY TASTES AND ITCHES.
 LET ME AT THOSE SONS OF BITCHES
 WHO HAVE TURNED THE WORLD TO KITSCH,
 WHICH MAKES THEIR WORN-OUT URGES . . .
 . . . twitch, twitch, twitch.
MAX:
 1 2 3 4 5 6 7
 WHAT WE DO *NOT* WANT IS HEAVEN.
 BETTER JUNGLE WITH ITS RIGORS
 THAN A WORLD—DULL FACTS AND FIGURES.
 MODERN SCIENCE AND ACHIEVEMENT
 BRING THE HUMAN SOUL BEREAVEMENT.
 LACK OF PRIMITIVE EXCITEMENT,
 NO MORE FOREIGN-LIKE DELIGHTMENT.
 I'M A DOCTOR, I CAN SEE IT:
 SPIRIT-SICKNESS HAS TO BE IT.
 JUNGLE GIVING WAY ITS GLORY
 TO A STERILE LABORATORY.
 HEROES USED TO GO EXPLORING,
 NOW EXPLOITING BEING BORING.

Lab. Otto sits writing. Rhoda enters. Nurse straps pencil to her leg.

OTTO: In fact, quite brave of you. Allowing these experiments to continue.

RHODA: Not brave, doctor. Desperate. Hoping for the worst.

OTTO: Understood, my dear. *(He rises, pulling table because his hand is strapped to it)* I too, for instance. Once—the dark continent—total risk. Now the best I can do is allow my hand to be strapped to this table, because my head is.

NURSE: No one feels like writing today?

RHODA: The bottom part of my leg's in the way.

OTTO: Chop it off, my dear.

Reveal man and axe head through holder. Rhoda screams.

BLACK MAX:
AFRICAAA!

NURSE: The top of the head's in the way.

RHODA: How can the head be in the way of something?

Ben laughs. Rhoda points to self.

I don't think *my* head is in the way of anything.

Axe falls, head chopped off. Cheers. Enter Three Headless Men.

OTTO: Therapy, my dear.

NURSE: Surgery, my dear.

OTTO: If thine eye offend thee . . .

Rhoda screams.

BEN:
CERTAIN BODIES
HAVE NO HEAD
IN A CERTAIN
WAY INSTEAD

HEADS ARE SIMPLY
SUPERSEDED,
HEADS IT SEEMS
NOT REALLY NEEDED.
IDEAS PLENTIFUL
 ALTHOUGH THE
HEAD'S NO LONGER
THERE TO KNOW IT.

ALL:

HEADS RE-MOVED
A
DIFFERENT KIND OF POWER GROWS.
WORLD'S IM-PROVED
AS
EVERYBODY STOPS DEPENDING
 ON THE THINGS HE THINKS HE KNOWS.

OTTO:

TEACH ME, TEACH ME
HOW TO LIVE
MINUS THOUGHTS
THE HEAD CAN GIVE.

USED TO USE IT
FIFTY-FIFTY,
USED TO FIND IT
KINDA NIFTY.

BEN & OTTO:

BUT YOU SAY
DEPENDENCY
ON THE HEAD
IS BAD FOR ME?

WESTERN THINKING
GETS TRANSCENDED.
META-PHYSICS GETS UP-ENDED.
FULL REVERSAL

ON THE SCALE
OF VALUES WE HAVE ALWAYS NEEDED.
NOW THOSE VALUES
 SUPERSEDED!

Rhoda and Eleanor with flowers.

RHODA: Remember those headless men?
ELEANOR: Very well.
RHODA *(Pause)*: I was attracted to one of them.
NURSE *(Kneels)*: My beloved—
ELEANOR: Which headless man did you find attractive?
RHODA: I don't know.
OTTO: Imagining the future, my dear?
RHODA: I can't tell.
ELEANOR: Try to describe him.
NURSE: But you have long known of my longing.

Rhoda sits. The chair dances out from under her. She screams.

ELEANOR: Hey—is this a chair?
MAX: The nineteenth century, my dear.
ELEANOR: Or is this an attractive, eligible bachelor?

Gong. She screams as Three Headless Men enter.

MAX: A headless man entered the room proclaiming, "Oh, my beloved. I have endured many adventures to find my way to your side!"
RHODA: But sir, how does a man of the nineteenth century speak, minus a head?
MAX: Alas, the headless man cannot answer that question.

Gong. He embraces her. Rhoda alone.

RHODA: Strange. A moment ago an attractive man was in this room. But what it was that was attractive about him, I could not say. His manner? His face? His smile?

ELEANOR: And the attractive chair said, "Oh! If the one I desire doesn't come to my cushions, then I no longer wish to exist!"

RHODA: Or to experience . . . further passionate adventures.

OTTO:

CERTAIN BODIES HAVE NO HEAD,
IN A CERTAIN WAY INSTEAD
HEADS ARE SIMPLY SUPERSEDED,
HEADS IT SEEMS NOT REALLY NEEDED,
IDEAS PLENTIFUL ALTHOUGH THE
HEAD'S NO LONGER THERE TO KNOW.

RHODA: It's strange—I'm dying of thirst and it's strange. Once upon a time, in the jungle I think, I was able to survive a week perhaps, with nothing to drink, nothing to eat—

NURSE (Shaking her head slowly): The nineteenth century, my dear.

BLACK MAX: Woman, why are you always striking provocative poses?

RHODA: Ah, you noticed at last? Strange. Can you tell me . . . why I am overcome . . . by a feeling of complete and total inertia?

BLACK MAX:

BLACK MAX—

RHODA: Please help me, someone.

BLACK MAX:

TURN INTO POETRY.

ALL:

BLACK MAX—
THOUGH HE DON'T KNOW IT
HE FILLS THE EMPTY MIND
WITH ROMANCE OF ANCIENT KIND.

BLACK MAX—

BLACK MAX:

FAR FROM AFRICA.

MEN:

SHOULD BE
QUITE A MATCH FOR HER.
WHICH, WATCH, MAKE—

NURSE:
A SNATCH FOR HER MIND.
ALL:
BLACK MAX—
BLACK MAX:
DON'T BE AFRAID OF HIM.
ALL:
BLACK MAX—
MEN:
LADIES WHO PLAYED WITH HIM—
ALL:
FIND HIM GENTLE AND KIND,
JUST THE SORT—
BLACK MAX:
TO EASE THE MIND.
ELEANOR: Here's an exciting idea—challenge me to an exciting game
of chess.
RHODA: I think the chess people have been glued permanently to the
chessboard.
ELEANOR: Try moving one of your chessmen, my dear.

*She makes a move. Figure is glued to the board, so whole
board slides to the floor. All scream.*

RHODA: You see the problem, my dear sister in paralyzed idiocy. *The
chess pieces are glued to the board!*

All scream.

ALL *(Fugue)*:
GLUED TO THE BOARD, GLUED TO THE BOARD . . .
OTTO:
TEACH ME
MAX:
HOW TO MOVE!

BLACK MAX:

> AFRICA, TAKE ME BACK TO AFRICA,
> TEACH ME BACK TO AFRICA,
> INSTRUCT US, INSTRUCT US,
> INSTRUCT US . . .

As rear doors open, all led by Nurse into blaze of mystic light and smoke.

RHODA *(Holding Eleanor back as music fades)*: No, no . . . don't follow them. Tempting though it may be, believe me, the problem has a more . . . adult solution.

ELEANOR: What problem?

RHODA: —There *must* be a better solution than continual dreams of escapism and exoticism—

ELEANOR *(Still held back)*: *What* problem?

RHODA *(Looks at her)*: *My* problem. Your problem.

ELEANOR: I don't have a problem, dear one.

RHODA: You have a problem, dear one—

ELEANOR *(Pause. Pulls away)*: Everyone has little problems.

RHODA: —Listen! Where would you rather be right now? Living this everyday life in this everyday world with its everyday problems and conventions and compromises—

ELEANOR *(Interrupts)*: —Of course not! I'd rather—

RHODA: Exactly! *(Quiet, intense)* At the edge of the unknown, with someone exciting at your side, moving through adventure after adventure after adventure—

ELEANOR: Don't contradict yourself, dear one. What very romantic sentiments you express.

RHODA *(Quiet)*: I know.

ELEANOR: I thought you said there was a better solution.

RHODA *(Pause)*: I was wrong. There is no solution.

Gong. Nurse enters followed by others in big masks. Violin music.

NURSE: First day of school, my dear. First day of school, my dear.

RHODA: I was finished with school long ago, thank you. And it seems that everything I learned there was a mistake, a misrepresentation, nothing but fantasy, pretense, lies.

NURSE: Don't be absurd, my dear. A whole world about to be opened to your young mind—

RHODA: It won't open. You don't open it. I don't know how to open it. It doesn't exist.

NURSE: In the imagination, with discipline . . .

RHODA: The imagination doesn't work. It's not enough!

NURSE:
DISCIPLINE!
DISCIPLINE!
THE BIG BLACK BOGEYMAN!

ELEANOR *(Overlaps)*: Uh-oh, I think something bad is happening—

NURSE *(Continuing)*:
FOR THE NAUGHTY . . .

RHODA *(Over end)*: I don't agree with this at all. I don't *believe* in this at all!

BLACK MAX: The choice is yours, my dear. Intellectualis effactatus.

Gong. He puts her over his knee and raises a hand into the air majestically, as if ready to spank.

Or the white man's creative, spiritual hunger, ever resourceful, ever expanding, conquering new realms and new worlds and new peoples. Or, if refused—the unpleasant alternative—the white man's burden, as they say.

AFRICANUS INSTRUCTUSSSSSSSSSSS!

ALL *(As he freezes with hand in air)*:
AFRICANUS INSTRUCTUS!
AFRICANUS INSTRUCTUS!

As this repeats, Rhoda is spanked slowly two times.

AFRICANUS INSTRUCTUS!

Fast and furious music becomes brilliant and loud. As this is happening, it marks Rhoda's escape from Black Max, and his throne glides rear. All keep singing, trying to spook Rhoda, who tours the stage fast, objecting to their ideas. As music climaxes, it cuts suddenly and she is alone center.

RHODA:

I AM SEARCHING FOR ADVENTURE
AND I'M RUNNING OUT OF TIME
'CAUSE THE WORLD IS GETTING SMALLER
AND ITS PROSPECTS DON'T SEEM FINE.

TO DISCOVER SOMETHING MAGIC
IN A COUNTRY FAR FROM HOME
SEEMS NO LONGER VERY LIKELY
SO I'M STRANDED HERE ALONE.

Hold.

BUT I HOPE YOU'LL GIVE ASSISTANCE
IN MY EFFORTS TO BE FREE
OF EMOTIONAL PARALYSIS
I WON'T LET CONQUER ME.

 ALL I
 ASK IS
 SHOW ME
WHAT YOU CAN DO.
 IF YOU
 THRILL ME
I PROMISE . . . I'LL THRILL YOU.

All dance frantically for two measures, then freeze.

ALL *(Loud)*:
 WON'T YOU
 SHOW ME
WHAT YOU CAN DO!

> IF YOU
> THRILL ME
> I PROMISE . . . I'LL THRILL YOU!

Band plays furiously as all try to thrill Rhoda and she doesn't respond. Then music cuts. All freeze.

BLACK MAX *(Far away)*:
> AFRICAAAA!

Rhoda stares out into the darkness of the theatre. Fade out.

YIDDISHER
TEDDY
BEARS

CAST

Hoffmeister: aging matinee idol type.
Mendle: sweet and wise barber-philosopher.
4 other men: God, gangsters, husbands, etc.

Clara: a young innocent from the country,
also plays old mother.

Bella ⎫
 ⎬ working girls.
Mona ⎭

SETTING

Lower East Side,
New York City,
turn of the century.

Hoffmeister in barber chair. Eyes closed, as Mendle the barber approaches with a white china bowl.

To side or rear, in dreamland, Hoffmeister's Mother is stirring in a similar mixing bowl.

MENDLE: Oh, elegant Hoffmeister, you are now dreaming for your very most recent, cute little Miss Current Hanky-Panky who is of course falling into the Hoffmeister clutches?

HOFFMEISTER: Ah, it's an amazement to me, Mendle, but I was for a moment not dreaming such things at all. But rather, dear Momma Hoffmeister from the old country—with making in the mixing bowl good things by the dozen for her little teddy bear for fressing—

MENDLE: Chicken soup, matzoh brei, momma's gefilte fish—

HOFFMEISTER: And her little teddy bear, always cleaning the plate.

MENDLE: Dat's what she called you?

HOFFMEISTER: Sure.

MENDLE: Her teddy bear?

HOFFMEISTER: I was not always the sophisticated ladies' man you got here now for tonsorial embellishment—

MOMMA *(Clara in disguise, sings)*:
TEDDY EAT GOOD AND PLENTY NOW,
MOMMA IS MIXING UP, AND HOW,
GOOD LITTLE THINGS FOR TEDDY TUMMY,
DOWN THE HATCH FROM LOVING MUMMY—

As she finishes, Mendle drops bowl on Hoffmeister's head, and lights go out on Mother. Hoffmeister sits up, startled, feels bowl on his head.

HOFFMEISTER: If you please, Mendle—what is this? Some grotesque new method with barbarous intention?

MENDLE: The latest in style, oh elegant Hoffmeister, who would set a certain heart aflame.

HOFFMEISTER: I would indeed. I have indeed.

MENDLE *(Sings)*:
WITH SONG, WITH AIR SO DEBONAIR—

HOFFMEISTER: The words out of the mouth you take, like sugar-cakes, Mr. Mendle, heretofore a most *reasonable* barber.

MENDLE:
OH, HOFFMEISTER JUNIOR, THE PRINCE OF THE
CITY,
WHO FASCINATES LADIES, WITH SUAVE NITTY-
GRITTY,
WITH TONGUE LUBRICATION TO OIL HIS PALAVER,
HE CONQUERS BY STYLE THOUGH THE MEANS
HARDLY MATTER.
HE USES HIS BRAIN IF HER MIND'S LITERARY.
HE USES HIS SMILE IF INSTEAD SHE'S CONTRARY.
BUT LATELY I HEARD OF HIS LATEST AFFECTION,
A LADY WITH TASTES IN A RUDER DIRECTION—

HOFFMEISTER:
MISS PEACHES AND CREAM, FRESHLY DOWN FROM
THE COUNTRY,
MY STYLE DEBONAIR STRIKES THAT KIND AS
EFFRONTERY.

MENDLE:
FOR SUCH I PROPOSE YOU, REMAKE A-LA-BUMPKIN,
TO PIERCE THE DEFENSE OF YOUR CUTE COUNTRY-
PUMPKIN.

HOFFMEISTER:
MISS KITTY CUM-PUNKIN, IT'S TRUE, TENDS TO
SLITHER
AWAY FROM MY CLUTCHES; MY HEART'S IN A
DITHER.
IF WORMING A KISS FROM THAT RUSTIC MISS PUSSY

TAKES BARBAROUS METHODS LIKE THIS, I'LL BE
WOOZY.

MENDLE:

PLEASE TO FIT THE BOWL UPON THE HEAD.
HAIRCUT LEADING TO A LADY'S BED
WITH THAT RUSTIC MISS WHO'S KINDA CUMFY
WITH A STYLE A LITTLE BIT GALUMPHY.
'CAUSE SHE'S GOT THE FEARS A MOMMA PLANTS
FOR THE TYPE IN CITY-SLICKER PANTS.
DON'T FIX UP LIKE ALL THE CITY BIGWIGS.
HERE'S A GIRL MORE COMFY WITH THE COWS AND
THE PIGS.

HOFFMEISTER:

MUST I REALLY ADAPT THE RURAL LOOK?
CAN I POSSIBLY HIDE MY SCHNOZZLE HOOK?
IS IT RIGHT TO SO TOTALLY DEFACE
SUCH AN ELEGANT MEMBER OF THE HUMAN RACE?

MENDLE: Just hold still a minute, Mr. Meyer Hoffmeister, and I will
conclude a transformation that will turn you, my elegant prince-
ling, into what Peaches and Cream Miss Kitty-Kat will go into
frothy frolic with farm-girl, frenzy-like friskiness.

HOFFMEISTER: No! I can't go through with the desecration!

MENDLE: Even for such a bundle of scrumptiousness itself?

HOFFMEISTER *(Trying to open door)*: Let me out ! . . . Let me out!

*Enter other door, Three Men like barbers with big scissors.
He sees them advance.*

HOFFMEISTER:

DON'T COME NEAR ME WITH YOUR SCISSORS.
DARE NOT TOUCH MY SILKEN LOCKS.
NOW I SEE THE PLOT BEHIND THIS!
JEALOUS HUSBANDS ARE A POX!

YES, I KNOW YOU EACH BY SURNAME,

SHARED BY SPOUSES IN DISTRESS
WHO REFUSE TO QUENCH THE FIRE THAT BURNS
INSIDE THEIR AMPLE BREASTS.

YES, I SERVE AN ANCIENT FUNCTION,
BRING A CERTAIN PLEASURE TO
LADIES WHO, THOUGH QUITE RESPECTABLE,
ARE *BORED* WITH MEN LIKE YOU!

OH HO! I'M
HOFFMEISTER JUNIOR, THE PRINCE OF THE CITY,
WHO FASCINATES LADIES WITH SUAVE NITTY-
 GRITTY.
WITH TONGUE LUBRICATION TO OIL MY PALAVER,
I CONQUER BY STYLE, THAT'S THE HEART OF THE
 MATTER.

FOR WIVES LIKE YOU GOT NEED A LITTLE
 EXCITEMENT.
SO I PROVIDE THAT SPICED WITH SEXY
 ENTICEMENT.
PROCLAIM FROM THE ROOFTOPS MY MASCULINE
 GLORY!
DON'T BLAME ME IF WIVES ASK FOR SWEET
 BEDTIME STORIES.

They advance on him.

Back, back, foul philistine husbands! Touch not the locks of one who unlocks imprisoned hearts which imprisoned never should be!

He rattles door.

Let me out of this den of vipers, beholden of barbarous barber tools!

He pulls out a gun and shoots. Men cower.

144

Cowards! Cowards!

Cut to office. Miss Clara and Boss.

BOSS: Ah, Miss Dimple-girl—
CLARA: Not my name, sir.
BOSS: This ain't no farm here, dearie. This here requires a different
maneuver to bring home the bacon, as they say, huh?
CLARA: Sir?
BOSS: Use the machine.
CLARA: It scares me a little, sir.
BOSS: A little scared is a little O.K. You push in the letter, you get
something on the paper, then you turn into a number one sec-re-
tary.
CLARA *(Typing one letter)*: Oh!
BOSS: What's wrong, dearie?
CLARA: Like an electric shock on my poor little finger. I think it was
on my finger, but my heart beats boom boom, sir.

Sings.

WHEN I BANG BANG, BANG BANG, BANG BANG
ON THE WRITING MACHINE,
I FEEL VICTIMIZED AND MEAN
AT THE SAME TIME.

WHEN I BANG BANG, BANG BANG, BANG BANG
MY CORONA DE-LUXE,
I GET JELLY-LIKE AND TOUGH
AT THE SAME TIME.

OH, THIS INSTRUMENT OF TORTURE
THAT YOU STRAPPED ME TO,
WRITING LETTERS, LETTERS, LETTERS
I DON'T WANT TO DO.

I PREFERRED IT ON THE FARM
WHERE I NEVER CAME TO HARM,

BUT TO SLAVE WITHIN THE CITY?
GIVE A WORKING GIRL YOUR PITY.

WHEN I BANG BANG, BANG BANG, BANG BANG
ON THIS TORTURE DEVICE,
MY EMOTIONS TURN TO ICE.
I'M A BAD GIRL.

WHEN I BANG BANG, BANG BANG, BANG BANG
I'D PREFER WITH A GUN.
FIRST I'D SHOOT YOU, THEN I'D RUN
TO THE COUNTRY.

FOR THE LIFE I RAN AWAY FROM
WASN'T BAD, I NOW FIND OUT.
'CAUSE A CITY SECRETARY
WANTS TO TEAR HER HAIR AND SHOUT.
SET ME FREE FROM CITY DUNGEONS
WHERE I'M SLAVE TO RAT-TAT-TAT,
TO GET FREE I'D GLADLY BLUDGEON
MR. CITY-CRAFTY RAT.

BOSS:
WATCH YOUR LANGUAGE, CHICKY-DICKY,
OR I'LL KEEP YOU AFTER WORK.
IF YOU'D LIKE TO GET YOUR DINNER,
SHUT YOUR MOUTH AND DO YOUR WORK.

IF YOU'D LIKE TO GET PROMOTED,
WHICH IS WHAT YOU GIRLIES DREAM,
I'LL PROVIDE YOU WITH A RECIPE
—BECOME MISS PEACH AND CREAMY

He gives her a kiss; she screams.

Don't scream!

Shots heard. Boss and Clara, as Hoffmeister bursts in, still in pot and sheet, with gun.

HOFFMEISTER: Nothing to scream about when all that happens is justifiable defense against such a finagle-able—

BOSS: We—I don't raise the cain like nothin'—compared to the you-know-who is standing me in front with such a dangerous weapon!

CLARA: Don't shoot, Mr. Hoffmeister!

HOFFMEISTER: A scum, not even?

BOSS: Who calls scum is some tip-top variety himself.

HOFFMEISTER: —Of a gentleman, sir. *(Dangles gun in mock horror)* Who is shocked to find an odious object seeming to dangle from a pinkie? Life thrusts upon us sometimes like a veritable hallucination of horribleness—

BOSS: Oh, tricky-philander-master-meister!

HOFFMEISTER: Away, away, horrible hallucination!

CLARA: I'll save you from this contaminating object, Mr. Hoffmeister!

She takes it between fingers to drop in pail.

HOFFMEISTER: A mere hallucination—

It goes off with a bang as it hits bottom. All scream. She rushes into Hoffmeister's arms.

HOFFMEISTER: Shhh, buttermilk maid of beauteousness.

BOSS *(Bellowing out in song)*:
AND THE CAT CALLS THE PITCHER
BLACK BLACK BLACK!!!

CHORUS:
BLACK, BLACK BLACK BLACK!
INKY POT BLACK!

Return to Hoffmeister in barber chair.

HOFFMEISTER: Hallucination, veritable human poetry-potency. What I want in my arms, I confess to you, Mendle barber buddy, to make a whirl like a squirrel, bushy tail gotcha, gotcha!

MENDLE *(Shaking his head)*: Ah, hallucinatin' the pussy cat of your dreams again.

Hoffmeister is whirling, in barber sheet, about the room, "Gotcha, gotcha, gotcha"—and bangs smack into the wall.

HOFFMEISTER: Ow! Wall—belonging to the category of things too solid, not like the yielding flesh category in the world standing between me, Hoffmeister, and desired female finale of fornication!

MENDLE: Clean up the language, please, for a public place?

HOFFMEISTER *(Drawing gun)*: You, too, Mendle?

MENDLE: Aie!

HOFFMEISTER: I detect another resistant to romantic fulfillment here!

As he wiggles his gun, God enters. Doorbell jingles.

GOD: Patience, my son.

MENDLE: Ohohoh! That's a Jehovah in my humble place of business himself? I can't believe—

GOD *(To Hoffmeister)*: Take my hand, son. Let fall to the earth—

HOFFMEISTER: Harmless toys, your highness, certainly—

GOD: —Weapon of violence and vanity.

HOFFMEISTER: You gotta point, your highness.

GOD *(Frowns)*: Point? What point?

HOFFMEISTER: *Your* help is always more potent than pistols.

He takes God's hand, writhes in pain.

Arughhh!

Sings.

IT HURTS A LITTLE BIT,
BUT THAT'S GOOD,
TO HURT A LITTLE BIT

THE WAY IT SHOULD.

WHEN YOU'VE BEEN BAD BAD BAD,
AND I KNOW YOU'VE BEEN,
MAKES ME SAD SAD SAD
WHICH I HIDE WITH A GRIN.

I WANT TO CHANGE A LOT
BUT I DON'T,
TO BE A BETTER MAN,
THOUGH I WON'T.

WHEN ALL YOU TRUST IS LUST,
AND THAT'S ME, ALAS,
NEED A HELPING HAND,
NOT A NEW PIECE OF ASS.

GOD:
NO NO! WASH THE MOUTH WITH *SOAP*, PLEASE!

HOFFMEISTER:
CAN'T SEEM TO HELP MYSELF
TO BE PURE.
WANT TO BEGIN AGAIN
WITH A CURE.

I TAKE THE HAND OF HIM
WHO'S THE HIGHEST ONE,
AND DEDICATE MYSELF
TO BE A DUTIFUL SON.

GOD:
DON'T EVEN TALK IN VAIN
ABOUT CHANGING YOUR LIFE.
DO THE PROPER THING.
MAKE A LADY YOUR WIFE.
WHEN THE KNOT'S BEEN TIED
WITH YOUR INNOCENT BRIDE,
KEEP THE PRESSURE COOKER DOWN
AND THROW FINAGLING ASIDE.

HOFFMEISTER:
>I WILL
>>I WILL
>>>I WILL!

BOTH:
>IT HURTS A LITTLE BIT,
>BUT THAT'S GOOD,
>TO HURT A LITTLE BIT,
>THE WAY IT SHOULD.

>WHEN YOU'VE (I'VE) BEEN BAD BAD BAD,
>LIKE I KNOW YOU'VE BEEN,
>TIME TO WASH THE HANDS OF SIN
>AND LET A NEW LIFE BEGIN.

Sink offered, Hoffmeister washes. Many blazing lights.

HOFFMEISTER: Ah—I got what here? Lights to show off the clean hands, huh? That must be a whole scheme—

Sings.

>THIS IS THE HIGHEST ONE.
>HE CAME TO VISIT ME.
>WITH SUCH A HEAVENLY GUEST
>I FEEL DELIGHTED.

GOD:
>LET'S HOPE MY VISIT HERE
>SINCERE REPENTANCE BRINGS.
>WHEN I MAKE PRIVATE CALLS,
>THAT'S QUITE EXPECTED.

MENDLE:
>WAS SUCH A BIG SURPRISE!
>I HAD TO POP THE EYES
>TO HAVE YOUR HIGHNESS
>VISIT MY ABODE.

HOFFMEISTER:
 TO FEEL YOUR PRIVATE CARES
 ON MY *PETITES AFFAIRES*
 ON ME DEPOSITS NOW
 A HEAVY LOAD.

GOD: That's to be hoped, my son.

HOFFMEISTER: Just one little detail. You got with you, I suppose—?

GOD: Speak up, my son.

HOFFMEISTER: Well, what I'm thinking here is some kind of verification, maybe?

MENDLE *(Waving a finger)*: Sacrilege, sacrilege, Hoffmeister.

HOFFMEISTER: Sorry. Experience teaches me, mere appearance ain't sometimes what it seems.

GOD *(Shaking his head)*: Tsk tsk tsk.

HOFFMEISTER: Who better than me, to testify a what might be called elegant exterior, can, under the covers—?

GOD: I am unique, my son.

HOFFMEISTER: Forgive me, sir.

He goes to door and opens it. Two Replicas of God enter.

HOFFMEISTER:
 OH GOD, MY GOD,
 THERE'S NOT A LOT TO SAY
 WHEN GOD, REAL GOD
 COMES DOWN TO HAVE HIS DAY.

 HIS WORDS, JUST WORDS,
 UNLESS HE MAKES A RUCKUS,
 'CAUSE GOD, REAL GOD
 WITH ACTS CAN RUN A-MUCK-US.

 HIS HOLINESS IS MYTHICAL IN MANY TALES AND
 STORIES.
 HIS COUNTERFEITED VERSIONS YET ACCOUNT FOR
 HALF HIS GLORIES.

I DON'T DENY PERHAPS HE SITS UPON A THRONE
ON HIGH.
BUT LOWER-GRADE IMPOSTORS CAN BE DEALING
ON THE SLY.

ALL:

OY YOY YOY!!!

HOFFMEISTER:

OH GOD, OH GOD,
WHICH ONE OF THEM IS REAL?
CAN MAN-I-FEST
LIKE KING OR LIKE SCHLEMIEL?

A BEARD, SO WEIRD
CAN MAKE A GOOD MAN DOUBT.
IF STYLE, JUST STYLE,
IS WHAT YOU'RE ALL ABOUT.

HIS HOLINESS IS NOT SUPPOSED TO HAVE AN IMAGE
CLEAR.
INVISIBLE TO EYES, IT'S JUST HIS VOICE YOU'RE
'SPOSED TO HEAR.
SO IF AN ANCIENT GRANDPA WITH THE SOULFUL
FACE APPEARS,
JUST KICK HIM OUT THE WINDOW AND FORGET
THE WHOLE GESCHMERE.

OH GOD, WHAT'S NEW?
YOU'RE MULTIPLE, IT SEEMS,
FOR ME, FOR YOU,
SO EACH ONE GETS HIS DREAMS.

A PROPER AND BEFITTING LORD OF HEAVEN ON HIS
THRONE,
WHO CONGREGATES AND CONCENTRATES ON
YOUR AFFAIRS ALONE.
IT'S WHAT THE RABBIS MUST HAVE MEANT, WHEN
SAYING GOD IS ONE.

IT MEANS TO EVERY SINNER THAT A PRIVATE
 VERSION COMES.

OH GOD, OH GOD,
YOU MULTIPLY LIKE MICE.
OH GOD, MY GOD,
THAT ISN'T VERY NICE.

OH GOD, MY GOD,
YOU'RE 'SPOSED TO BE JUST ONE.
IF YOU APPEAR IN TRIPLICATE
I'LL SHOOT YOU WITH MY GUN—

*He takes out gun. Gods whip off masks, are seen to be Three
Police.*

HOFFMEISTER:
 WHAT'S DIS? WHO'S DIS?
POLICE:
 OH, WE HEARD ABOUT A FELLA
 WHO WAS CARRYING A GUN.
 SO WE THOUGHT WE'D BETTER CATCH HIM
 AND CONTROL HIS LITTLE FUN.
 'CAUSE INSIDE THIS HAPPY CITY
 WE GOT RULES AND WE GOT LAWS.
 AND IF FOREIGN FELLAS BREAK 'EM,
 WE'LL GO SNATCH 'EM IN OUR CLAWS!

 'CAUSE THE HEAVY HAND OF JUSTICE
 IN THIS YOUNGSTER U.S.A.
 SAYS TO SLIMY SLIPPERY FOREIGN TYPES,
 PLAY STRAIGHT OR GO AWAY.
HOFFMEISTER:
 OH GOD, MY GOD,
 POLICE IN THAT DISGUISE
 IS SURE TO BRING
 DISASTER FROM THE SKIES.

TO TAKE IN VAIN
THE IMAGE OF THE LORD
WILL BRING DOWN HERE
DISRUPTION AND DISCORD.

POLICE:

DON'T FINAGLE OUT OF THIS
WITH NEW ACQUIRED PIETY.
WE GOT QUITE A DOSSIER HERE
OF SOMEONE'S NOTORIETY.

LET'S PRODUCE A CERTAIN LIST
OF TWENTY WIVES AND MAIDENS,
INNOCENT UNTIL THEY KISSED
A CERTAIN MISTER *CRAVEN,*

WHO'S BEEN KNOWN TO PROMISE
WHAT MAKES FOOLISH FEMALES FLUTTER,
LICKING OFF THE CREAM WHILE MELTING
LOTS OF HEARTS HE TURNED TO BUTTER.

ALL:

OHH!
HOFFMEISTER JUNIOR, THE PRINCE OF THE CITY,
YOUR ESCAPADE'S FINISHED, WE'LL SHOW YOU NO
PITY.
WE COME WITH THE RAZOR OF MORAL
CORRECTION,
TO FIX UP YOUR LIFE IN A PURER DIRECTION.

THE LOCKS THAT WE SHAVE FROM THIS NOGGIN
SEDUCTIVE
WILL EDUCATE FEMALES IN WAYS QUITE
PRODUCTIVE.
TRANSFORMING THIS HEAD TO A SCHNOZZLED
POTATO
WILL OPEN THE EYES OF BAMBOOZLED TOMATOES!

HOFFMEISTER *(As they prepare him, sings)*:
THE LADIES WHO FOUND ME BOTH SUAVE AND
 ATTRACTIVE
I FEAR WON'T CONSIDER MY CHARMS
 RETROACTIVE.
MY LOCKS IF YOU CUT THEM I FEAR WILL DEPRIVE
 ME
OF SENSUAL CONTACT WITH PASSIONS THAT DRIVE
 ME.

Music continues as they cut.

OY! OY! OY!

He bounds from the chair, holding mirror.

The pieces of hair fall, my God, and the complete manhood falls,
too, in manliness, no? Have a look at this, please! Like no less a
virgin babe, violated, devalued, debased, deflowered!

Office: three Girls, typing.

GIRLS:
ALMOST TIME TO FINISH WORKING,
WHEN WE HEAR THE BELL WE YELL
SECRETARIES LIVE IN HELL,
NEVER COMING BACK HERE.

BUT TOMORROW THE ALARM CLOCK
TINGLES HERE'S ANOTHER DAY!
GOTTA WORK TO EARN DA PAY.
GONNA BE A BLACK YEAR.
MONA:
'CAUSE A GIRLIE'S GOT TO STRUGGLE
JUST TO KEEP HERSELF ALIVE.
IF SHE GETS HERSELF IN TROUBLE,
BLAME A WORLD WHERE MEN CONNIVE.

BELLA:

TO EXPLOIT HER LACK OF KNOWLEDGE
AND HER INNOCENCE AND TRUST,
'CAUSE SHE NEVER WENT TO COLLEGE,
NOR IMAGINED WHAT WAS "LUST."

BOTH:

SAD TO FIND THAT MEN SHE'S TRUSTED
USUALLY TURN OUT TO BE
POPPA-LIKE UNTIL SHE FINDS THEY'VE ALL GOT
GREAT BIG FAMILIES—

CLARA *(Sings, mocking)*:

A FAMILY MAN . . .

ALL:

GIRLS GIRLS GIRLS,
IT'S WORKING GIRLS, WE MEAN,
LEARN THAT MEN IN FANCY SUITS
ARE NEVER WHAT THEY SEEM.

GIRLS GIRLS GIRLS
WHO SWEAT TO EARN YER PAY,
KNOW THAT MEN WHO TREAT YOU NICE
EXPECT TO GET THEIR WAY.

Bell rings. Girls cheer and start to run out, grabbing bags, etc., but stopped by Boss.

BOSS:

LADIES, LADIES,
IT'S TRUE
THAT YOU'RE THROUGH
FOR THE DAY.

BUT I'VE AN ADDITION
TO YOUR WORKING CONDITION:
A FEE YOU PAY.

DON'T LOOK SO UPSET.

IT'S JUST THAT I GET
SO LITTLE AFFECTION.

A DAUGHTERLY KISS
YOU NEVER WILL MISS.
I KEEP A COLLECTION

TO COMFORT MY NOODLE.
SOME FIDDLE AND FADDLE
BEFORE YOU SKADOODLE.

CLARA: Let me get this straight!

BELLA: Oh no!

CLARA: To get out of work, you want us to—

BELLA: Ugh!

CLARA: Give you a *kiss?*

BOSS: Why not? I'm old enough to be your *poppa*. Give a kiss to poppa.

CLARA: Ugh!

BELLA: Ech!!

MONA *(More sophisticated, sings)*:
GIRLS, PERHAPS WE'RE OVERREACTING.
EACH MAN'S GOT AN INNER MUST-SCRATCH THING,
A GEEZER, AS MUCH AS A STALLION,
CAN CHARGE, LIKE A TOTAL BATTALION.

CLARA *(Aside)*: Oh that Mona! She's just a tart in disguise!

BOSS: Now *dis* lady got some understanding—

CLARA: We understand, too, right, Bella?

BELLA: Well, Clara, she's taking advantage of the situation.

CLARA: Right!

BELLA: Where does that leave *us?*

CLARA: Huh?

BELLA:
ME, TOO, TAKES A WIDER PERSPECTIVE—

CLARA: Oh no! Bella!

BELLA:
CAREER, THAT'S MY MAJOR OBJECTIVE.

A MAN THAT GETS PLEASED BY A LADY
CAN HELP MAKE A GRAY DAY A PAY DAY.

CLARA: I don't want to work in such a den of . . . of . . . of . . . even if
I need the money to pay off for my . . . *(She cries)*

BELLA AND MONA:

A GIRL'S GOTTA USE EVERY FEATURE
TO LIVE, LIKE A COMFORTABLE CREATURE,
BE SWEET, WHEN THE MOMENT REQUIRES
TO TRADE, WITH THE SELLERS AND BUYERS.

CLARA *(In tears)*: No no no!

Enter Hoffmeister, wearing hat.

HOFFMEISTER:

WHEN I HEAR THE CRY
OF THE APPLE OF MY EYE,
I AM ACTING LIKE A HERO
THOUGH MY SEX APPEAL IS ZERO.

SINCE MY HAIR GOT CUT
I GOT ALL THE TIME A HAT,
'CAUSE THIS FUZZY THING ON TOP
MAKES THE PALPITATIONS STOP
OF THE FEMALES WHO BEFORE
USED TO LINE UP AT THE DOOR.

BUT I STILL WILL CROSS THE STREET
TO PROTECT A DAMSEL SWEET.
FROM A MAIDEN IN A TIZZY—
GETS THE INNER FEELINGS BUSY.

BOSS: Hey, Hoffmeister, don'cha like a gentleman take off a hat in a
lady's presence? Haha!

*Mona and Bella laugh, too. Hoffmeister molds hat tight on
head.*

HOFFMEISTER:

MISSY PEACHES HERE IS CRYIN'

SO HEROICS I AM TRYIN'
BUT IT'S HARD TO GO TO BAT
WHEN YOU'RE HOLDIN' DOWN A HAT.

CLARA:

I APPRECIATE THE EFFORT
'CAUSE I KNOW YOU'RE IN A FIX.
SO TO PLEASE DON'T SPEND THE EFFORT
ON A GIRLIE FROM THE STICKS.

HOFFMEISTER:

JUST BECAUSE I GOT SOME TROUBLE
WITH THE STYLE OF MY COIFFURE,
STILL I SERVE A LADY'S TROUBLE
'CAUSE MY SENTIMENTS STAY PURE.

MONA AND BELLA:

OH, WE'D LIKE TO SEE THE NOGGIN
THAT'S BEEN RECENTLY REDONE,
'CAUSE IT USED TO BE SEDUCTIVE,
NOW THE VENGEANCE SHOULD BE FUN.

BOSS:

TO ENJOY A LITTLE GIGGLE
HOW THE MIGHTY TUMBLE DOWN,
TIME TO SEE THE LITTLE SECRET
WHAT'S THE JOKE ALL OVER TOWN.

He rips off hat.

THAT'S HOFFMEISTER JUNIOR, THE PRINCE OF THE
CITY . . .

Pause—Girls laugh.

WITH AIR DEBONAIR,
BUT WITH HAIR ITSY-BITSY.

MONA: Gee, can I touch it?

BOSS: Touch that? That's a fuzzy lookin' thing! Haha!

BELLA: Kinda cute.

HOFFMEISTER: Cute, you say?

CLARA: It ain't so bad, Mr. Hoffmeister.

MONA: Yeah, don't go hiding your cute little bushel under a *hat*.

BELLA: That's a cute little bundle.

HOFFMEISTER: Ladies, mock not, please, a man who always for the female population—

BELLA: No, no, it's really *cute*.

HOFFMEISTER: —Me?

BOSS: Him?

CLARA: You know, Mr. Hoffmeister Junior, I got a secret to tell.

Sings.

WHEN YOU WAS KINDA HANDSOMER,
THE SLEEK AND SILKY TYPE,
A GIRL COULD DREAM, ROMANCIN' HER
WITH FANCY GIFTS EACH NIGHT.

BUT ME, WHO'S JUST A COUNTRY GIRL
SO RECENT FROM THE FARM,
THAT MORE SOPHISTICATED YOU,
CAUSED ME A LITTLE BIT ALARM.

HOFFMEISTER:
BUT WHY?

CLARA:
'CAUSE I BEEN SCARED A LITTLE BIT
TO SEE YOU GIVE THE EYE
TO MY NAIVE AND SIMPLE MAIDEN-
HOOD I'D LIKE TO CRY.
MY HANDS WAS SHAKIN', KNEES WAS QUAKIN'
WHEN I SEE YOU TOOK
AN INTEREST IN A GIRL
WHO'D NEVER EVEN READ THE BOOK,
ABOUT THE WAY TO ACT WHEN
YOU'VE A GENTLEMAN IN TOW,

THE THINGS TO DO,
THE THINGS TO SAY,

I SIMPLY DIDN'T KNOW.

BUT NOW THAT YOUR ROMANTIC PROFILE
ALTERS FOR THE BEST—
NO LONGER WITH THE WAVY LOCKS
MAKES BANG BANG BANG THE HEART BEAT
BIG INSIDE A MAIDEN'S BREAST.

BELLA AND MONA:

OH, HE'S SO *CUTE* NOW
NOTHING TO FEAR NOW,
NO BIG GESCHMERE NOW
NOT VERY SCAREY,
CUTE FUZZY-HAIR-Y.

CLARA:

MY LITTLE YIDDISHER BEAR
WITH THE FUZZY HAIR,
WON'T YOU COME AND PLAY WITH ME?

WITH YER SCHNOZZLE THING
CAN'T WE PUT THE RING
ON THE PINKY
SO WE HINKY
DINKY-HITCHED
CAN BE?

OH MY YIDDISHER BEAR
LET ME TOUSLE THE HAIR
WHERE MY FINGERS LOVE TO PLAY.
LIKE THE COUPLE WE MAKE
IN THE OVEN WE BAKE
LOTS OF TINY LITTLE COOKIES
IN THE CRANNIES
AND THE NOOKIES.

FOR OUR YIDDISHER HOUSE
WE GOT YIDDISHER MOUSE,

WITH THE CATS THE MICE ALL PLAY
 OH HO HO

MY YIDDISHER BEAR
WITH THE FUZZY HAIR,
WHAT I LOVE TO HUG AND SQUEEZE.

TO MY HEART I TOOK
THE MESHUGENAH LOOK
AND I WANT TO BE THE MISSES
SO I GET
LOTS OF KISSES.

FROM MY YIDDISHER BEAR
THROUGH THE FOUL AND FAIR
WE CAN HAVE A LIFE SO FINE.

'CAUSE A TEDDY BEAR LIKE THAT
WHEN HE'S TAKEN OFF THE HAT
TRADES A HEART FOR A HAT WHAT'S MINE.

She trades his hat with her heart, pulled out from blouse.

TEDDY WAS A JEW.
HE DIDN'T CHOOSE TO BE A JEW
BUT WHEN HE LOOKED,
HE GOT A BIG SURPRISE.

RIGHT THERE IN THE MIDDLE
OF HIS FACE HE GOT A PIDDLE
EMIGRATED
INTO MAJOR SIZE.

POPPA BEAR WAS SHOUTIN'
WHAT'S THAT SCHNOZZLE ON HIS SNOUT 'N'
WHY'S HE GOT THAT DREAMY LOOKIN'
WITH HIS EYES?

COMES FROM ALL THAT READIN'

WHICH NO NORMAL BEAR IS NEEDIN'
SO I GOTTA MAKE
A HORRIBLE SURMISE.

WHEN I MET HIS MOTHER
SHE SEEMED DIFFERENT FROM THE OTHER
BEARS, BUT FAM-I-LY
FROM HER SHE NEVER SAID.

NOW I SEE THE REASON.
'CAUSE IT WAS THE MATIN' SEASON,
 MY GOD—
 A GRIZZLY—THAT'S ME

TOOK A JEW—THAT'S HER
INTO HIS BED
I SHOULD RATHER BE DEAD.

Slow beat.

YIDDISHER TEDDY BEAR
 BOW WOW
YIDDISHER TEDDY BEAR
 AND HOW
LOTS OF OTHER ANIMALS ARE CUTE TO SEE
NONE OF THEM GOT QUITE THE SAME APPEAL TO
 ME.

YIDDISHER TEDDY BEAR
 PING PONG
YIDDISHER TEDDY BEAR
 DING DONG
MOMMA AND THE POPPA AND THE BABY TOO,
SOON THEY'LL BE ENOUGH TO MAKE A YIDDISHER
 STEW.

YIDDISHER TEDDY BEAR
 WOOF WOOF

YIDDISHER I DON'T CARE
 PIFF POOF
ALL OF THE BAD-NIKS, BLAMING A JEW,
TURN INTO GLAD-NICKS, WHEN THEY SEE YOU.

 OH

YIDDISHER BEAR
YIDDISHER BEAR
MAKE MY YIDDISHER DREAMS COME TRUE.

HE'S SO CUTE
HE'S SO CUTE
USED TO CRITICIZE HIM FOR A SLIMY GALOOT.

HE'S SO CUTE.
HE'S SO FINE.
TIME WE GOTTA CELEBRATE
A SPECIAL SALUTE TO
YIDDISHER BEAR!
YIDDISHER BEAR!

DEEP DOWN YIDDISHER
BUT NOBODY CARES.

SO CUTE TEDDY,
TAKE HIM TO HOME.
HUGGIN' HIM AND KISSIN' HIM
WHEN YOU'RE ALL ALONE.

JEWS AND GENTILES
GOTTA AGREE,
YIDDISHER TEDDY
DATS SOMETIN' TO SEE—

Repeat verses as desired.

Mendle discovered alone in his barber shop.

MENDLE: Oy—is the world changing fast? You tell me—First, all the

Jews, making crazy with trying to catch up one way or another with the Goyim styles with the cars and the fancy clothes and the girls and foolin' around that's not meant for the Jewish people!

Absolutely like Hoffmeister for instance in particular, who I'm not saying is not a nice Jewish fella, but oh boy with the ladies!

Then he gets finally a good trim for those wavy locks what makes ladies with conniptions—

But what happens—that seems he still got a way to do some finagling, which after that serious haircut I thought would be finished, 'cause it's the very worst thing I can imagine a nice Jewish fella doing with the gifts God gave him.

Bell jingles, as Bella and Mona enter.

MONA: Mendle—do you cut ladies with the newest things?
BELLA: Bobbing the hair, Mr. Mendle?
MENDLE: Ladies with *bobbing*! See what I'm talking? What's happening to nice Jewish girls?

Bella and Mona rip off wigs to reveal bobbed hair under, sticking out tongues at Mendle.

MENDLE: Oy you—!

Sings.

THE END OF AN ERA
OR TWO OR THREE
I HATE TO SEE
FATUZZLES ME.
LET'S HOW ABOUT KEEPING THE WAY IT WAS.
THAT'S GOOD ENOUGH FOR ME.
BELLA AND MONA:
DON'T BE A STICK IN THE MUD, MR. MENDLE.
TIMES ARE CHANGING FAST.
IF YOU DON'T KEEP WITH THE CHANGING, MENDLE,

YOU'LL GET STUCK IN THE PAST!

MENDLE:

THE LADIES AND GENTLEMEN
CHANGING STYLE
IS QUITE A TRIAL
SHOULD STOP A WHILE.

THE WAY THAT THE JEWISH LIFE USED TO BE
IS GOOD ENOUGH FOR ME.

BELLA AND MONA:

—POOH POOH!

MENDLE:

'CAUSE ME I READ MY HISTORY
AND KNOW WHAT HISTORY SHOWS.

THE WORLD SO HOT TO CHANGE A LOT
MAKES MENDLE HOLD HIS NOSE.

THE JEWISH LIFE AIN'T GOT TO DO
WITH FANCY NEW IDEAS.
THE JEWISH LIFE IS BEST FOR YOU.
SO STOP THE SHIFTING GEARS.

OF PROGRESS THAT'S FOR GOYIM WHO
WOULD LIKE TO SPIT ON ME, NOT YOU.
DON'T THINK WITH THAT NEW FANCY HAIR
YOU'LL HOITY-TOITY EVE-ER-RY-WHERE . . .

—OHHHHH OH OH—

THE HAIRCUT'S NEW
BUT YOU'RE A JEW.
THERE IS A TRAP
IN ALL OF THAT.
THE GENTILE WORLD
WITH HISTORY PLAYS.
BUT JEW SHOULD LIVE
UNCHANGING UNIVERSAL DAYS.

Enter Louis XIV.

LOUIS:

 I GOT MYSELF A NUMBER.

 LOUIS FOURTEEN WAS MY NAME.

 MY FANCY DRESS WAS WONDERFUL.

 OY VEY, IT WAS A SHAME.

 WHEN LOUIS FIFTEEN CAME ALONG,

 AN ERA DIED WITH ME.

 I THOUGHT I CHANGED THE WORLD FOR GOOD,

 BUT PROGRESS PUNCTURED ME.

CHORUS:

 OH JEWS, STAY OUT OF HISTORY.

 IT'S GOT SOME BAD SURPRISES.

 GO BACK AND STUDY TORAH.

 LET GOYIM WEAR DISGUISES.

 OF BIG HISTORIC PERSONAGE

 WHAT PLAYS AROUND WITH FATE,

 BUT FINDS WHEN TIME IS UP THEY

 CAME IN FIRST BUT FINISHED LATE!

Enter Henry VIII with tray with Anne B's head.

HENRY VIII:

 I GOT MYSELF A NUMBER.

 CALL ME HENRY NUMBER EIGHT.

 MY WIVES WAS ALSO NUMEROUS.

 HERE'S ONE ON THIS HERE PLATE.

 I'D LIKE TO THINK I'M GENEROUS,

 BUT LOVE CANNOT ENDURE

 WHEN SPREAD TO GIRLS WHO NEEDS IT,

 LIKE THE ROSES NEED MANURE.

CHORUS:

 OH JEWS, STAY OUT OF HISTORY.

 IT'S GOT SOME BAD SURPRISES.

 GO BACK AND STUDY TORAH.

LET GOYIM WEAR DISGUISES.

OF BIG HISTORIC PERSONAGE
WHAT PLAYS AROUND WITH FATE
BUT FINDS WHEN TIME IS UP THEY
CAME IN FIRST BUT FINISHED LATE!

Napoleon enters.

NAPOLEON:
I GOT MYSELF A NUMBER,
WHAT'S NAPOLEON THE FIRST,
WID OTHER EMPERORS AFTER ME,
BUT SOME OF THEM WAS WORSE.
THE BATTLES I WAS WINNING
WAS TO ME A MAJOR JOY,
TILL CLOCK TICK-TOCK OF HISTORY
CALLS ME A NAUGHTY BOY.

CHORUS:
OH JEWS, STAY OUT OF HISTORY.
IT'S GOT SOME BAD SURPRISES.
GO BACK AND STUDY TORAH.
LET GOYIM WEAR DISGUISES.

OF BIG HISTORIC PERSONAGE
WHAT PLAYS AROUND WITH FATE
BUT FINDS WHEN TIME IS UP THEY
CAME IN FIRST BUT FINISHED LATE!

Movie Star enters.

MOVIE STAR:
I HAD MYSELF A NUMBER,
ME, BOX OFFICE NUMBER ONE.
THE LADIES USED TO SCREAM FOR ME,
BUT NOW MY RULE IS DONE.
THE FICKLE PUBLIC TURNED AWAY.
SO WHO THEY THOUGHT WAS CHIC

IS ME WHO'S IN THE COLD NOW: TIME
TO TURN THE OTHER CHEEK.

CHORUS:

OH JEWS, STAY OUT OF HISTORY.
IT'S GOT SOME BAD SURPRISES.
GO BACK AND STUDY TORAH.
LET GOYIM WEAR DISGUISES.

OF BIG HISTORIC PERSONAGE
WHAT PLAYS AROUND WITH FATE
BUT FINDS WHEN TIME IS UP THEY
CAME IN FIRST BUT FINISHED LATE!

HOFFMEISTER *(Still short hair, stares at Movie Star)*: My God, I see something that reminds me—

He looks at himself in hand mirror, to compare self to Movie Star.

MENDLE: Ah, that was in another time, Mr. Hoffmeister.

HOFFMEISTER: Am I looking into a mirror?

MENDLE: —We was younger.

HOFFMEISTER: —or a *mirror?*

MENDLE: For us it's finished! Good riddance!

HOFFMEISTER: Does time march on like this?

Sings.

I DREAMED I HAD A NUMBER
THAT WAS WRITTEN ON MY WRIST,
WAS INK, I THINK, WHO WROTE IT THERE,
THAT'S ONE THING THAT I MISSED.
I TRY TO SCRAPE IT OFF THE WRIST
AND FIND TO MY SURPRISE
MY NUMBER'S KINDA PERMANENT.
IT'S BURNING BOTH MY EYES!

CHORUS:

OH JEWS, STAY OUT OF HISTORY.

IT'S GOT SOME BAD SURPRISES.
GO BACK AND STUDY TORAH.
LET GOYIM WEAR DISGUISES.

OF BIG HISTORIC PERSONAGE
WHAT PLAYS AROUND WITH FATE
BUT FINDS WHEN TIME IS UP THEY
CAME IN FIRST BUT FINISHED LATE!

MENDLE:

SO LIVE A LIFE IN PRIVATE
WITH FAMILY, THAT'S ENOUGH.
NO NEED TO BE A BIG SHOT
WITH SHOWING OFF YOUR STUFF.
'CAUSE JUST BEHIND THE CORNER
IS LURKING THERE FOR YOU
SOME RABBLE WITH THE STICKS AND STONES
TO FIDDLE WITH A JEW.

HE'LL MAKE YOU DANCE
YOU'LL LOSE YOUR PANTS
IT WON'T BE SO MUCH FUN.
SO SNEAK AROUND
STAY UNDERGROUND
THAT'S MY ADVICE TO YOU, A JEW.

HOFFMEISTER: Ah, that's hard advice for a man like me to follow Mr. Barber Mendle—

MENDLE:

THAT'S MY ADVICE TO YOU.

HOFFMEISTER: Let me have a little recollection for the Hoffmeister style, which ain't that at all.

MENDLE: It's a new era for you.

HOFFMEISTER: —the way I used to play around with all the ladies?

MENDLE: True, true, but would you say you got the same equipment?

HOFFMEISTER (Sadly): True, the equipment wears out a little. But. Turn a problem into a solution. People seem to find me all of a

sudden kinda cute, cuddly, like you wanna wrap it in a package and take it home to momma—

MENDLE: Hoffmeister, well enough alone—

HOFFMEISTER: We wrap it in a package and we take it home to momma!

MENDLE: What's that?

HOFFMEISTER: Look at this cute kisser— *(He goes behind bear cutout with place for head)* We gotta million dollar novelty item here—

MENDLE: No, no, Hoffmeister, don't traffic with the world.

HOFFMEISTER: Why not?

MENDLE: Bad stuff rubs off on a Jew what has traffic with the world.

HOFFMEISTER: You mean, we shouldn't *try* to make worldly successful things? —I'm not talking here finagling.

MENDLE: *I'm* not talking here finagling!

HOFFMEISTER: Me neither!

Clara enters with box.

CLARA: Oh, Hoffy, darling. Here we got twenty-five more charming little Jewish teddy bears all packed up for shipment direct to Zinzinatti in Ohio.

MENDLE: Oy oy oy.

CLARA: What's wrong with Mr. Mendle?

MENDLE:

DON'T TRY TO MAKE A BUNDLE IN THE BUSINESS WORLD,
'CAUSE THE BUSINESS WORLD MAKES FOR SELFISH AND FOR GREEDY.
WITH A JEW HE'S GOT A SOUL, DON'T PUT IT UP FOR SALE,

FOR A SOUL FOR SALE,
 MEANS ANOTHER
 SLEAZY.

BUSINESSMAN

WANTS TO MAKE A PILE
HE'LL RESORT TO
TRICKINESS AND GUILE.

BUSINESSMAN
SHOULDN'T BE A JEW
'CAUSE THE BUSINESS WORLD
WOULD BE BAD FOR YOU.

CLARA:

WHAT ELSE CAN WE DO?
WE GOTTA MAKE A LIVING.
THESE TEDDY BEARS
MUCH HAPPINESS IS GIVING.

HOFFMEISTER (*Taking out a teddy*): Look, Mendle, it's me. All the
cute little boys and girls—they get a cute little Hoffmeister bear
for under the Christmas tree.

Three Xmas Trees enter.

MENDLE: Oy oy oy!

HOFFMEISTER:

DON'T BE AFRAID OF XMAS
WHEN IT'S XMAS TIME FOR A JEW,
'CAUSE THE TEDDY BEAR IS SELLING
AND THE MONEY BOX IS SWELLING,
SO THE JEWISH SANTA CLAUS IS
 FAIRY TALE COME TRUE!

DON'T BE AFRAID OF XMAS
WHEN IT'S XMAS TIME FOR A JEW,
'CAUSE THE XMAS TREE IS BLINKIN'
SO TO ALL THE WORLD I'M WINKIN',
AS I'M THINKIN' MERRY CHRISTMAS TO YOU.

HERE'S A FANCY HORAH FOR THE HOLIDAYS.
ALL THE CHRISTIAN WORLD IS GONTA GET AMAZED

WHEN THEY SEE THE JEW NO LONGER GHETTO-
 BASED
MAKES A JEWISH KILLING IN THE MARKETPLACE.

CLARA:

HORAH, MENORAH, 'N' PLUS THE XMAS TREE
MELTING POT AMERICA
THE WAY IT'S GONNA BE.

HOFFMEISTER:

JEWISH, COME TRUISH
DREAM ABOUT SUCCESS.
CLIMB THE MONEY MOUNTAIN
ON THE BUSINESSMAN EXPRESS.

VOICE *(Over speakers)*: Twenty-five more Jewish teddy bears for the
nice towns of Battle Creek, Indy-appulus, and the Grand Rapids,
Meshugaas—all aboard with the Jewish teddy bears!

Open to mechanized teddies on shelves.

CHORUS:

DON'T BE AFRAID OF XMAS
WHEN IT'S XMAS TIME FOR A JEW,
'CAUSE THE TEDDY BEAR IS SELLIN',
AND THE MONEY BOX IS SWELLIN'
SO THE JEWISH SANTA CLAUS IS
 FAIRY TALE COME TRUE!

DON'T BE AFRAID OF XMAS
WHEN IT'S XMAS TIME FOR A JEW,
'CAUSE THE CHRISTMAS TREE IS BLINKIN',
SO TO ALL THE WORLD I'M WINKIN'
THINKIN' MERRY XMAS TO YOU.

1. 2. 3. 4. 5. 6. 7. 8.
TEDDY BEARS IS PART OF EVERY HOUSEHOLD.
9. 10. 11. 12. 13. 14. 15. 16.

DANCING WITH THE CHRISTIANS AND THE JEW.

17. 18. 19. 20. 21. 22. 23. 24.

TEDDY BEARS DE OTHER DOLLIES OUTSOLD.
25. 26. 27. 28. 29. 30. 31. 32.

JOIN THE BUSINESS WORLD AND SPREAD THE NEWS!

OH DON'T BE AFRAID OF XMAS
JUST BECAUSE IT ISN'T FOR JEWS.
YOU CAN MAKE IT XMAS FOR THE PEOPLE OF THE
 BOOK WHO LOOK
AT XMAS TIME WITH HORROR
'CAUSE FOR THEM THERE'S NO TOMORROR.

BUT TOMORROW CAN BE RICHER
MILK AND HONEY EVERY PITCHER
WILL BE FLOWING OVER TOP
WHEN THE PROFITS NEVER STOP.

JUST TO SAY HELLO TO SANTA
SHOCKS THE RABBI AND THE CANTOR
WHO WOULD RATHER YOU'D BE CHANTING
SOME UPLIFTING JEWISH RANTING.
BUT DON'T LISTEN TO THE ARGUMENTS
FOR TURNING BACK THE CLOCK.
'CAUSE IT'S BETTER TO BE GOYISH
THAN TO BE A JEW IN HOCK.

YES, IT'S BETTER TO BE GOYISH
THAN TO BE A JEW IN HOCK.

Enter two well-dressed Thugs.

THUG 1: O.K. We come for the dogs.
HOFFMEISTER: What's that?
THUG 2: Hey, Jewboy, we come for the dogs!
VOICE *(Over speaker)*: Saying that changed everything. O.K., we've

come for the dogs, seemed, on the surface of things, to indicate a simple expansion of merchandizing success for the Jewish businessman. But deeper significance was ready to fall that day, like a ton of bricks, and the chosen people for the chosen target of that heavy load was in this case, anything but random.

THUG 1: You got yourself into the toy market? O.K. Cute little product: only you stick your nose in where other noses are before you.

THUG 2: Yeah, all noses are equal, of course. But some noses are *more* equal.

THUG 1: So, Jewboy—

HOFFMEISTER: Why do you call me Jewboy—?

THUG 2: Ain't you a Jew?

HOFFMEISTER: Yes, I'm a Jewish gentleman.

MENDLE: —See what trouble you got now?

THUG 2: O.K. Jewish gentleman. We're gentlemen, too. We allow you to keep up with manufacturing these things—only we take care of distribution plus a 75 percent share off the top of everything.

HOFFMEISTER: 75 percentage!

MENDLE *(Nods knowingly)*: Off the top of everything.

CLARA: Highway robbery is not permissible!

HOFFMEISTER: Very true. We don't go into cahoots with that, gentlemen.

THUG 1: Oh? No cahoots—?

THUG 2 *(As Thug 1 takes box of bears)*: Talk English with us, buddy.

HOFFMEISTER: Hey! What you doing with the teddies?

MENDLE: What did I say, Hoffmeister? Don't get busy with the business world—

THUG 2: Good advice.

MENDLE: —because the Jewish people, sir, got hearts and feelings that don't mix with the cutthroats who just make the profits with stepping on people and smashing right and left the teachings of the Torah, for instance.

Thug 1 has other box of teddies, and is throwing them in the garbage.

HOFFMEISTER: Please, stop what you're doing to the teddy bears!

THUG 2: 75 percent.

HOFFMEISTER *(Thinks)*: How about 50?

MENDLE: Don't make a deal with such people!

THUG 2: 75?

HOFFMEISTER: 55?

THUG 1: Where I come from, Jewboy, nobody haggles.

CLARA: What would your mother say to see what you do to the nice teddy bears?

THUG 1: Leave my mother outta this.

HOFFMEISTER: What you got, a nice Italian momma?

THUG 1: I ain't no Wop. *(Indicates Thug 2)* He's the Wop. I'm Polish.

THUG 3 *(Entering)*: I'm the driver. I'm a greasy Greek!

MENDLE: A nice melting pot, here.

THUG 1: 75 percent or all the bears get trashed!

HOFFMEISTER: Aye! You're right, Mendle, life was better when I was just playing around with the girlies—

MENDLE: Hoffmeister, you're always with finding a method for making God look at you for an example and being unhappy.

HOFFMEISTER: I'm making God unhappy?

MENDLE: Total unhappy!

HOFFMEISTER: I'm so busy crying in the soup, I didn't notice.

THUG 2 *(Carrying in)*: More teddies for the trash bin!

CLARA *(In tears)*: Oh no no!

Sings.

JEWISH TEDDY BEARS
WHAT'S GOING INTO GARBAGE,
WHERE'S THE GOD ABOVE
THAT'S STOPPING FROM ON HIGH THIS

TERRIBLE AND SAD

DEMISE FOR LITTLE TOYS?
EYES GET FULL OF TEARS
FROM LITTLE GIRLS AND BOYS.
HOFFMEISTER: We'll make a deal—
THUG 2: We don't make deals.
CLARA: Don't make a deal with such people!

Sings again.

JEWISH TEDDY BEARS
WHAT COULD HAVE BEEN FOR LOVING
TO THE GARBAGE HEAP.
THE BITTER TEARS IS COMING
WHEN A TEDDY BEAR
WHO NEVER DID A CRIME
FINDS HE'S IN THE GARBAGE PAIL.
THAT SHOWS IT'S CLOSING TIME.

FOR THE DREAM OF THE JEW
WHO WAS INNOCENT LIKE YOU
WHEN YOU HAD YOUR LITTLE TEDDY
AND THE DREAMS INSIDE HIS HEAD, HE
HAD LIKE ALL THE TEDDIES DO,
MOMMAS GAVE TO ME AND YOU—
THUG 1: I told you, keep the mommas outta dis!
CLARA:
FOR THE DREAMS OF THE JEW
WHEN HIS DREAMS WAS SHINING NEW
WAS A GENTLE WORLD OF TEDDIES
WHO GOT HUGGED BY ME AND YOU.

BUT THE DREAM'S GOT A TICKET
TO A PLACE, HE DIDN'T PICK IT,
LOOKED A LITTLE BIT LIKE VAT Y'CALL IT HERE.

AND THE DREAM GOT SO TIRED
THAT IT COULDN'T EVEN CRY, IT

FOUND A WAY TO MAKE HIS TEDDY DISAPPEAR.

THUG: 75 percent.

HOFFMEISTER *(Looking at his wife in tears)*: O.K. For my darling
 Clara.

CLARA *(Angry)*: I don't wanna hear from this!

She slams out of the room.

HOFFMEISTER *(Calls after)*: I'm doing for you, to keep the teddy
 bear from the garbage! You want him in the city dump? In the
 cement mixer? and the big ovens, too?

THUG: 75 percent.

HOFFMEISTER *(Looks at him, then sings)*:
 I'M HOFFMEISTER JUNIOR, THE PRINCE OF THE
 CITY.
 I'LL SHAKE ON THE DEAL, THOUGH MY SHARE'S
 KIND OF SHITTY.
 FOR LOVE OF THE LADY I MARRIED WITH
 SWEARING
 HER COMFORT AND SHELTER I'D ALWAYS BE
 CARING.

 IF SHE WANTS A CADILLAC, THAT'S WHAT I'LL GET
 HER.
 THE TOYS MAY BE CUTE, BUT BRING CASH WHAT
 PROTECTS HER.
 SO MAYBE I HAVE TO MAKE DEALS WITH SOME
 GANGSTERS.
 TO THRIVE GOT TO END UP A BIT HANKY-
 PANKSTER.

THUG: 75 percent.

HOFFMEISTER: O.K., with that, my friend. *(Aside)* But I don't have
 to tell you to your face what I think of you behind your back.

THUG 2: Huh?

THUG 1: Let the Jewboy think what he likes. So long as he pays the 75
 percent.

HOFFMEISTER:

BEHIND HIS BACK I SING TO HIM
SO I WILL NOT GET HIT.
I THINK HE'S JUST A BIG SCHLEMIEL
SHOULD END UP IN THE SHIT.

ALAS THE WORLD IS VERY CRUEL
TO JEWS ESPECIALLY.
SO COMES THE DAY THIS SCHNOOK GETS HIS.

Hold—as he speaks over.

I'm so old already that the wonderful smack this one, too, is gonna get someday from the Good Lord, let's hope—

Sings again.

I WON'T BE THERE TO SEE.

The Thugs laugh.

THUG 1: Right, Jewboy.

Clara bounds in with a flit gun; she sprays.

CLARA: Oy, is there a bad smell in here, Hoffmeister. What can I use this perfume to sweeten up a little?
THUG 2: —Hey, cut out that perfume!
CLARA: Maybe you *need* a little perfume?
THUG 1 *(Grabs Hoffmeister)*: You sayin' we stink, Jewboy?
HOFFMEISTER: I'm not a Jewboy no longer or I'd give a punch in the nose.
CLARA *(Taking a deep breath)*: Wop! Wop! Mr. first class *Wop!*

All look at her stunned, as she sings.

THE WORLD IS FULL OF PREJUDICE,
SO LET ME TAKE MY SHARE.
THE JEWISH PEOPLE SUFFERED THAT.
IT DIDN'T SEEM SO FAIR.

BUT NOW I GOT A GREAT IDEA
TO EVEN UP THE SCORE,
INSULTING YOU WITH WORDS I'LL DO:
WITH YOU I'LL MOP THE FLOOR.

HEY, MR. WOP, YOU GOT A LOT
SPAGHETTI IN THE POT.
BUT WHEN I'M THROUGH INSULTING YOU
YOU'LL HIDE YOUR NOODLE, IN DISGRACE.

OH, MR. WOP, YOU GREASY LOT
YOU GOT DA MEATBALL MIND.
COMPARED IT TO A BRAINY JEW—
BY STUDYING YOUR FAT BEHIND.

THUGS: Hey—!

CLARA:

YOUR POLACK PAL IS EVEN MORE
RETARDED THAN A WOP.
THE POLISH JOKE WITH HUMAN LEGS
DAT'S ALL THE POLISH COUNTRY GOT.

CLARA AND HOFFMEISTER:

THE WORLD IS FULL OF PREJUDICE,
SO NOW WE GOT OUR OWN,
FOR CALLING BAD, INSULTING NAMES—
WE TAKE A FEW ON LOAN.
FROM ALL THE ONES BEEN HURLED AT US
SINCE HIS-TOR-Y BEGAN,
AND NOW WE START INSULTING BACK
WITH ALL THE MIGHT WE CAN!

CLARA:

THE DIRTY GREEK IS JUST A PEEK
INTO THE GARBAGE PAIL
OF OTHER FILTHY PEOPLE WHO
WITH FILTHY NAILS AND SLIMY TALES—

LIKE PIGS WITH RATS AND GREASY HOGS

WHAT MESSES UP THE WORLD,
THE JEWS WILL YELL AND HURT THEIR EARS
WITH DIRTY WORDS, YOU'LL BLUSH WITH SHAME.

MENDLE:

OH JEWS—DON'T START WITH PREJUDICE LIKE
 OTHER PEOPLE DO.
YOUR WORDS WILL GO FROM HOUSE TO HOUSE
AND THEN COME BACK TO YOU.

TO USE THE WORDS TO CALL A PERSON
SOMETHING VERY BAD
WILL CAPTURE GOD'S ATTENTION AND
WILL HE GET PRETTY MAD!

OY YOY YOY!

Mendle exits.

THUGS: Come on, come on—

They sing.

STICKS AND STONE CAN BREAK OUR BONES,
BUT WORDS DON'T HURT AT ALL,
ESPECIALLY WHEN A LITTLE YID'S
THE ONE WHO SAYS THEM ALL!

CLARA AND HOFFMEISTER: Oy yoy yoy!

Sing.

THE WOP, THE MICK, THE DIRTY SPIC,
THEY'RE ALWAYS IN CAHOOTS,
WHEN JEWISH PEOPLE TRY TO RISE
THEY KICK THEM WITH THEIR BOOTS.

FROM PARADISE AND OTHER NICE
AND FANCY GOYISH PLACES,
THEY SEND THEM BACK

TO GHETTOS AS TEARS
 RUN DOWN
 JEWISH FACES.

THUGS:

HEY KIKES YOU GOTTA LOTTA NERVE
TO USE THOSE DIRTY NAMES.
IT MEANS YOU BETTER BE PREPARED
TO PLAY SOME DIRTY GAMES.

CLARA AND HOFFMEISTER *(Defiant)*:

OH HO HO!

THE WORLD IS FULL OF WOPS AND CHINKS.
WITH NIGGERS, KRAUTS AND GOOKS
ARE DOING BUSINESS EVERY DAY,
EXCHANGING DIRTY LOOKS.

THAT MUTUAL HOSTILITY
WHAT GREASES UP THE WHEELS,
IT'S TIME THE JEWS GOT INTO THAT
TO FIND OUT HOW IT FEELS!

THUGS:

OH, IS DAT WHAT YOUSE WANTS?

Shifting tune, ominous.

WE'RE GONNA WRITE SOME EPITAPHS,
THE WORST YOU'VE EVER SEEN.
SELECTED JEWISH WINDOW PANES
WILL SHOW YA WHAT WE MEAN.

CLARA AND HOFFMEISTER:

AND THEN WE WILL SHOUT BACK TO YOU
MUCH WORSER ONES THAN THAT.
THE JEWISH BRAINS WILL THINK THEM UP.
YOU CAN'T COMPETE WITH THAT!

THUGS:

OHHHH, YOU YID!

CLARA AND HOFFMEISTER:
OH, YOU GOYIM GARBAGE.
THUGS:
KIKES ARE ALL ALIKE.
CLARA AND HOFFMEISTER:
THE GOYIM ALL LIKE TRASH IS.

Mendle enters as God again.

MENDLE:
ENOUGH! ENOUGH!
THIS TERRIBLE BEHAVIOR
MAKES FUN OF ALL MY LABOR!

I NEVER WANT TO HEAR A JEW
USE WORDS LIKE THAT AGAIN,
NOT EVEN THINK THEM SILENTLY,
NOT CHILDREN, WIVES OR MEN.

Indicates Thugs.

THESE OTHER PEOPLE AREN'T EXACTLY IN MY
 JURISDICTION,
BUT IF I COULD I'D ALSO THEM
 MAKE CERTAIN WORD RESTRICTIONS.
HOFFMEISTER: Ah—dat's just Mendle with a disguise on top.
MENDLE: Oh? You don't believe your eyes?

Sings.

LITTLE JEW, IT'S FOR YOU,
THAT I'M TAKING THIS APPEARANCE.
IF MY REAL FACE APPEARED,
IT WOULD CAUSE YOUR DISAPPEARANCE,
'CAUSE MY LIGHT GETS SO BRIGHT
WHEN IT'S REALLY WHO I AM,
THAT TO SEE, YOU MUST BE
A COMPLETE AND *WORTHY* JEWISH MAN!

HOFFMEISTER *(Not terribly confident)*: That's what I *am*—
CLARA: Me, too!

Thugs laugh in operatic: HAHAHAHAHA!

MENDLE:
LITTLE JEWS, IF I CHOOSE
TO APPROACH IN DISGUISES,
IT'S BECAUSE HOW YOU ACT
GIVES ME VERY BAD SURPRISES.
WHEN YOU USE ALL THE WORDS
FROM THE GUTTER WHAT I HEAR,
THAT MAKES CLEAR—THE MESSIAAAAH—

—gotta lotta work to do with you before he can finally appear!

Hoffmeister rips off Mendle's God mask.

HOFFMEISTER: See? I told you who that was—just Mendle!
MENDLE: Mendle, the *Jew!*
HOFFMEISTER: That's what I said.
MENDLE: Is Hoffmeister still the Jew? Or is Hoffmeister changing
into something different from a Jew?
THUGS: He's still a Jew!
THUG 2: —Once a Jew, always a Jew. You got your wish.

They exit, laughing.

MENDLE *(To Hoffmeister)*: You tell me, is that true?

Bella and Mona appear as old ladies.

LADIES, LADIES,
DO YOU RECOGNIZE A JEW?
IF A JEW BEHAVES A WAY
THAT BRINGS DISGRACE UPON A JEW?

ONCE HE'S A JEW,
IS HE ALWAYS A JEW?
OR IS

BEING A JEW
SOMETHING HARDER THAT YOU GOTTA
 FIND YOUR WAY . . . IN . . . TO?
HOFFMEISTER:

WHAT MAKES A JEW?
ONCE I THOUGHT THAT I KNEW.
IF YOUR MOMMA WAS A JEW,
AUTOMATICALLY THAT YOU
WOULD BE JEWISH COMPLETELY,
THAT DEFINED IT KINDA NEATLY.
NOW YOU'RE TELLING ME NOT SO.
MENDLE:

TO BE A JEW YOU GOTTA GROW
INTO EVERYTHING YOU KNOW
THAT A GOOD JEW SHOULD DO.
HOFFMEISTER:

—WHICH TO ME SOUNDS EXTREME,
THOUGH IN A WAY . . .
 I KNOW WHAT YOU MEAN.
MENDLE: What do I mean?

HOFFMEISTER: It used to be so different, Mendle. Life—remember years ago, what it seems?

MENDLE: Sure, I remember that.

HOFFMEISTER: You was always saying to me—"Hoffmeister, stop with all the chasing ladies all the time."

Mona and Bella giggle.

MENDLE: I certainly remember that.

HOFFMEISTER: But now, looking at that backwards—was that really so terrible I was chasing the ladies a little? I mean, in comparison?

MENDLE: In comparison, no.

BELLA AND MONA: That was O.K., Hoffmeister Junior—

Sing.

THE PRINCE OF THE CITY . . .

HOFFMEISTER: —See? Some kinda idea occurs to me, Mendle, that when a Jew is a little chasing the petticoats—at least two things.

MENDLE: What two things?

HOFFMEISTER: One! He's not getting his fingers into the business world, which is a cutthroat thing that the Good Lord never said, "That's O.K. by me."

MENDLE *(Sad)*: But as you told me many times, the Jew has to live, too.

HOFFMEISTER: Two!—

MENDLE: Too?

HOFFMEISTER: Two by two?! Was that God's plan, or was that God's plan! Two by two, into the ark, for example, by couples only.

MENDLE: Yeah, but you, Hoffmeister . . .

HOFFMEISTER: —So I made a few *extra* couples. But still that was a relationship to God's plan.

Sings.

TWO BY TWO, MEANS A JEW AND A LADY JEW,
NOT SO BAD A PLAN WHEN YOU EXAMINE IN
 REVIEW.
OCCUPYING HOURS WITH THE LADIES KINDA
 FLIRTY
WAS A THING THAT YOU COULD CRITICIZE—
BUT WHO GOT REALLY HURT?

THEY CALLED ME . . .
BELLA AND MONA:
 HOFFMEISTER JUNIOR, THE PRINCE OF THE CITY!
HOFFMEISTER:
 WITH NICE JEWISH LADIES, ALL CHARMING AND
 PRETTY.

BELLA AND MONA:
> HE WASN'T, FOR PARENTS, THE KIND THEY WOULD
> FAVOR,
> HIS FANCY, NON-JEWISH, SEDUCTIVE BEHAVIOR
>
> MAKES MOMMAS GET WORRIED.

HOFFMEISTER:
> BUT SECRETLY FLUSTERED,
> THEIR FEELINGS IN TURMOIL WAS NOT TO BE
> TRUSTED,
> 'CAUSE PASSION'S DA FASHION, WHATEVER THE
> SYSTEM
> OF MORAL PERSUASION YOU'RE TRYIN' TO LIVE IN.
>
> SO HOFFMEISTER JUNIOR, SO PLEASE TO
> REMEMBER,
> WAS LOOKED DOWN THE NOSES, BY JEWS, NO
> DEFENDER
> WAS FOUND TO EXPOUND THAT HIS PASSION FOR
> LADIES
> WAS MAYBE HIS OWN WAY TO SING TO GOD'S
> PRAISES.
>
> FOR NICE JEWISH WOMEN, HIS NEED TO BE WITH
> THEM
> IS MAYBE FOR MANKIND THE BEST THING HE'S
> GIVEN
> TO KEEP IN HIS HEART, WHILE HE'S TOILING WITH
> SORROW,
> THE HOPE FOR A GENTLE AND JEWISH TOMORROW.
>
> 'CAUSE LADIES TO WORSHIP IS MAYBE SOLUTION
> TO PROBLEMS OF SORROW AND MORAL
> POLLUTION.
> 'CAUSE GOD NEVER COMES DOWN TO HELP AND
> PROTECT US,
> BUT NICE JEWISH LADIES WILL NEVER NEGLECT US.

SO LIVE A LIFE, WITH LOVE AS KING.
DON'T WORSHIP ANY OTHER THING.
THAT HOLY BOOK, MORALITY,
WON'T LOAD WITH FRUITS
THE JEWISH FAMILY TREE.

THE HEART'S THE THING THAT KEEPS A MAN
IN TUNE WITH NATURE'S MASTER PLAN,
MAKE JEWS OF BOTH THE SEXES FREE,
UNLOCKED WITH LOVING'S MASTER KEY!

THE SINFUL STUFF WAS LOTS OF LIES.
YOU SEEN BEFORE YOUR VERY EYES
THIS JEW WAS BETTER OFF WHEN HE
WAS HIGHLY ACTIVE SEXUALLY.

'CAUSE WHEN REPRESSED, HIS FEELINGS GROW
IN BAD DIRECTIONS DOWN BELOW.
AND WHEN THAT PRESSURE GETS A LOT
ONE VERY SCREWED UP JEW YOU'VE GOT!
WHO'S FULL OF HATE AND QUITE PERVERSE.
FROM GENTILES, HE IS EVEN WORSE,
BECAUSE HE GOT UNCONSCIOUS THINGS
THAT'S WHAT THE SEX REPRESSION BRINGS!

Sings out—bellows.

SO JEWS . . . GO BACK!
TO UN . . . REPRESSED
AND FULL . . . EXPRESSED
LACIV . . . IOUSNESS

THE PLEA . . . SURE WHAT
SOME LO . . . VING BRINGS
WILL FIX . . . FOR YOU
100 MILLION LOUSY PSYCHOLOGICAL THINGS!

The real Moses appears, on tall shoes, carrying ten

commandments. Voice on tape, so it can be real basso profundo.

MOSES:

JEWS! JEWS! WHO DISAPPOINT ME ALL THE TIME—

HOFFMEISTER: That's Mendle again.

CLARA: But Mendle's here—

MOSES:

WITH YOUR FANCY PANTSY THEORIES
WHAT YOU START TO THINK'S AS GOOD AS MINE.

JEWS, JEWS, YOU'RE ALWAYS IN THE SHIT.
I GIVE A CLEAR INSTRUCTION,
BUT YOU NEVER FOLLOW IT.

I TOLD YOU NOT TO STEAL AND NOT
TO COVET LOTS OF WOMEN.
WHAT'S MORE, I SAID, DO CERTAIN THINGS
AND THEN MY WORD IS GIVEN
THAT VERY HAPPY YOU SHALL BE,
BUT EVEN WITH ALL THAT
YOU KEEP BEHAVING BAD AND MAKE
A THEORY OUT OF THAT.

SO STOP, DESIST AND CEASE, WHAT'S MORE,
HOW COME YOU LOOK AT ME?
REMEMBER THAT MY FACE AND FORM
YOU'RE NOT SUPPOSED TO SEE.

YOU GOT A GOD, BE SURE OF THAT,
WHO'S WATCHING WHAT YOU DO.
HE'S TOTALLY INVISIBLE—
SO LOOKING'S NOT FOR YOU!

WITH SEEING ME'S A FIGMENT
FROM THE OVERACTIVE BRAIN
THAT GETS YOU INTO TROUBLE TIMES
 A MILLION TIMES AGAIN!

HOFFMEISTER: So you come here, confusing everybody crazy—
what are we supposed to do?

MOSES: Ah, Hoffmeister, you think it's dat simple? When you got a
problem, all you gotta do is ask *me* all your questions. What I'm
supposed to have a personal answer for *you* in *particular?* That's
a fancy idea, Hoffmeister.

HOFFMEISTER: But you're talkin' to me right now.

MOSES: Is that what you think I got time for?

HOFFMEISTER: But ain't you there talkin' to me?

MOSES: Don't you know the story? God makes himself a world, so it
takes almost a week. But a very little time passes, a couple
centuries maybe. So then he's got better things to spend his time
worrying.

HOFFMEISTER *(As darkness descends)*: So what they're talkin' to
me. Nothing? That's what you are, a big *nothin'?*

A crash of thunder and screams.

MOSES *(Out of dark)*: You call *that* nothin'? Huh?

HOFFMEISTER *(Shaking with fear)*: Well, no. But you just said—

MOSES *(From darkness)*: I said a big mouthful! What I'm gettin' at—
that's for me to know and you to figure out!

Another crash and all but Mendle scream.

MENDLE: I'm afraid, Hoffmeister—what I wouldn't speak for God,
of course, but the explanation is beyond what you call human
understanding.

HOFFMEISTER: And that's what I'm supposed to be satisfied?

MENDLE: What else choice?

HOFFMEISTER: What I want—some answers!

MENDLE: Answers?

HOFFMEISTER: I want, the Lord God himself, he should give with
some answers.

MENDLE: You wanna bring down the whole kit and kaboodle?

HOFFMEISTER: After all this time! Kit and kaboodle or no kit and
kaboodle—

MENDLE: —Gettin' a little big for the britches, maybe?

HOFFMEISTER: Listen! Listen! You ain't talkin' with no spring chicken here—

MENDLE: A little wet behind the ears—

HOFFMEISTER: With all I went through already, I should have the grey hairs down to the shoes and *socks!*

MENDLE: So what you need's another *haircut*, maybe—

HOFFMEISTER: No haircuts.

MENDLE: Remember the haircut!?

HOFFMEISTER: Listen—I get a haircut when I don't want a haircut? I just get with more *angry*, that's all!

Sings.

LIKE SAMSON PULLED THE TEMPLE DOWN
SO WHAT HE CRACKED HIS CROWN?
IT DIDN'T BOTHER HIM TO SEE
THOSE PILLARS FALLEN DOWN.

THEY CUT HIS HAIR TO MAKE HIM THINK
HE DIDN'T HAVE HIS MUSCLE,
BUT HE STOOD UP AND SHOWED 'EM
HE WAS READY FOR A TUSSLE.

THAT'S LIKE ME!
DON'T GET ME VERY MAD!
THEN YOU'LL SEE
A JEW THAT'S BIG AND BAD.

LIKE JACOB HAS AN ANGEL COME
TO SEE IF HE COULD WRESTLE,
SAID, "ANGEL, TREAD MORE CAREFULLY
'CAUSE YOU'RE THE WEAKER VESSEL!"

THE ANGEL COULDN'T GET A PIN
'CAUSE JACOB'S GOOD CONDITION
MEANT EVEN USING WINGS THE ANGEL
LOST DAT COMPETITION!

THAT'S LIKE ME!
DON'T GET ME VERY MAD!
THEN YOU'LL SEE
A JEW WHAT'S BIG AND BAD.

TODAY I GOT SOME ENEMIES.
TOMORROW WILL BE DOUBLE.
'CAUSE IF YOU ARE A JEW YOU ALWAYS
FIND YOURSELF IN TROUBLE.

IF GOD DON'T WANNA HELP ME
THEN I'LL DO IT FOR MY OWN.
I'LL BATTLE ALL MY ENEMIES
WID MORE THAN STICK AND STONE.

IN BIBLE TIMES
THAT WORKED O.K.
FOR TINY LITTLE DAVID.
SO ME, I'M NEAR
THE END OF MY LIFE
BUT STILL I WANT TO SAVE IT!

Little teddies are illuminated.

MY TEDDY BEARS, WHO LOOK LIKE ME,
FROM WHAT THEY STEAL MY PROFITS,
I GOT AN INSPIRATION—

Hold.

I'LL FILL TEDDY BEARS WITH *ROCKETS!*

AND WHEN THOSE DIRTY CROOKS TAKE TEDDY
 BEARS AND PAY ME ZERO,
MY TEDDIES WILL EXPLODE AND I'LL BE
JEWISH BATTLE HERO!
CLARA *(Shocked at idea)*: Hoffmeister!
HOFFMEISTER:
 TEDDY'S REVENGE!

NOW I'M LOOKING FORWARD!
TEDDY'S REVENGE—

CLARA:

—I HATE AND DEPLORE IT!

A TEDDY BEAR FOR BOMBS,
THAT OUGHT TO BE VERBOTEN!

HOFFMEISTER:

THIS TEDDY'S BEEN HARMED
SO STOP WITH SUGAR COATIN'.
THE IDEA WHAT JEWS
IS GETTIN' PUSHED AROUND
IS STOPPIN' WHEN DIS TEDDY MAKES
DA BIG EXPLOSIVE SOUND!

*Giant explosion. Teddies fall from ceiling in smoke and fire.
Giant Teddy or two march in with bloody swords and
mixing bowls on heads for helmets.*

USED TO BE THAT TEDDY WAS A
PUPIL IN THE SCRUPLE WAY OF
LIVING BUT THAT DIDN'T
GET HIM FAR.

NOW HE'S GOT THE NOTION THAT THE
WARRIOR'S EMOTION IS THE
FEELING THAT WILL LIFT HIM
TO THE STARS.

DON'T YOU TRY TO CROSS HIM 'CAUSE HE
WANTED TO BE THE BOSS 'N'
NOW HE'S STRONGER THAN HE EVER
WAS BEFORE.

SO IF YOU SHOULD GIGGLE
WHEN YOU SEE HIS MUSCLES JIGGLE,
THAT'S FOR SHOWING HOW HE'S GOING
INTO WAR!

March song.

BELLA AND MONA:
> TEDDY
> HAS STOPPED BEING CUTE!
> HE'S WEARING
> THE BIG SOLDIER SUIT.
> HE'S MAKING AN ARMY
> OF YIDDISHER BEARS.
> HE'S READY FOR FIGHTING
> IF ANYONE DARES!
>
> TEDDY
> IS READY
> TO BUST
> A HEAD, ONE OR TWO
> IF HE MUST,
> AND IF YOU DON'T GIVE IN
> IT MIGHT BE A MILLION,
> 'CAUSE TEDDY
> SAYS WINNING'S
> A MUST
>
> FOR US, OH
> WINNING A MUST IS
> FOR US!
>
> SAYS TEDDY,
> WINNING FOR US
> IS A MUST!

CLARA *(Begins singing heroic, pacifist song, then into lullaby; to side, imitating a momma, with a mixing bowl, sings a kind of sad song as she mixes, over fading march beat)*:
> IS THAT WHAT YOU WANTED,
> THE WHOLE WORLD IN FLAMES?
> THE TEDDIES BRING VENGEANCE
> 'CAUSE THEY'RE THINKING WHAT'S TO BLAME.

IS THE JEWISH TEDDY CERTAIN
THAT THE VENGEANCE WILL BE SWEET
'CAUSE THEY DREAM ABOUT THE BAD ONES
ON WHOSE FACE THEY WIPE THEIR FEET?

BUT I BET A MILLION DOLLARS
WHEN HE'S LOOKED AT WHAT HE'S DONE,
TEDDY STARTS TO FEEL UNHAPPY
THAT SUCH TRAGEDY HAS COME.

AND HE'S MORE AND MORE UNHAPPY
WITH A MIX-UP DEEP INSIDE
'CAUSE HE TRIED TO MAKE WITH JUSTICE
BUT THE LORD WAS NOT HIS GUIDE.

Angel appears and sings, too.

ANGEL AND CLARA:
SO HE TOOK UPON HIS SHOULDERS
TELLING BAD FROM TELLING GOOD,
MAKING CERTAIN KINDS OF JUDGMENTS
WHAT HE KNOWS HE NEVER SHOULD.

SO I FEEL SO BAD FOR TEDDY—
CLARA:
—THAT I WANT TO MAKE HIM GOOD,
SO I'M MIXING UP SOME PORRIDGE
LIKE A MOMMA ALWAYS SHOULD.

Hold, looks over to Hoffmeister, who lights up in rocking chair.

KEEP HIM DRESSING LIKE A GENTLEMAN
AND THREE SQUARE MEALS A DAY,
WITH A HAIRCUT AND THE SHOES SHINED
HE'LL GO FAR IN LIFE THAT WAY.

IN HIS SCHOOLWORK IF HE STUDIES,
GOES TO TEMPLE WHEN HE SHOULD,

IS THERE SOMETHING ELSE TO GUARANTEE
MY TEDDY ENDS UP GOOD?

*A bowl is placed over Hoffmeister's head by Angel, as
Mendle puts around barber sheet.*

HOFFMEISTER *(Low, in reverie)*: Oy . . . oy . . . What kind of haircut
you giving here, Mendle?

MENDLE: Ah, can't go wrong, Mr. Hoffmeister. It's a new system I
got. It's Mendle's own Jewish triumph of tonsorial technology.

HOFFMEISTER: Hey, you know what, Mendle? With this thing *(He
raps on it with his knuckles)* I got a good solid protection for the
noggin.

They both laugh. Mendle knocks, too.

MENDLE: My own invention—

HOFFMEISTER: Very brainy Mendle, if I say so. With this thing, I got
a good solid protection.

MENDLE: That's *good!*

HOFFMEISTER: —No meanie can crack with no Jews' heads, if the
Jews' heads is wearin' this beanie.

MENDLE: I should patent maybe?

HOFFMEISTER: Oh please, Mendle! Keep it a secret for the Jewish
noodle! The protective beanie against the meanie!

And the Jew is safe!—Amazing, Mendle. It's a solution the Jewish
people have been looking for, for hundreds of years, maybe even
more—

Sings.

WE GOT A
NICE JEWISH BEEEEEANIE

NOT A MEANIE
COULD CRACK THAT POT,

WHATEVER HE'S GOT,
WITH A HAMMER OR CHISEL

WOULD JUST BE A FLOP.
SO STOP, WHAT YOU BOP,

WOULD JUST BE A FLOP.O STOP, WHAT YOU BOP,

THEY'LL NEVER GET IN SUCH A BEANIE,
SO THE JEW CELEBRATES WITH A GRIN.

'CAUSE THE MEANIES OF THE WORLD
CAN ATTACK WITH ALL THEIR MIGHT
BUT THE LATEST JEWISH BEANIE
MEANS THE JEWS'LL BE ALL RIGHT.

SO CHEER FOR THE JEWISH BEANIE
WHICH COVERS THE HEAD WHICH IS GOOD,
'CAUSE THE BRAINS OF A JEW—
AND HE'S GOT QUITE A FEW—
WILL BE SAFE IN THE BEANIE TONIGHT!

Fast xylophone solo on bowls now seen on several heads.
Three players, three covered heads.

HERE WE GOT A MODERN KINDA YARMULKE
MAKES IT SAFE FOR SAYING JEWISH PRAYERS.
NOTHING CAN GET THROUGH FOR CAUSING HARM
 IN THERE
EVEN IF THEY PUSH YOU DOWN THE STAIRS!

THAT'S THANKS TO THE JEWISH BEANIE
WHICH COVERS THE HEAD ALL AROUND,
WITH A BOWL LIKE A HAT
MAKES A YARMULKE THAT
IS THE BEST THAT'S BEEN EVER FOUND!

THANKS TO THE JEWISH THINKER
WHO TINKERED TO COME UP WITH THAT.
WITH THE BEANIE ON HIS NOODLE
GIVES THE JEWISH YANKEE DOODLE
SOMETHING BETTER THAN A FEATHER IN HIS CAP!

THANK THE JEWISH GODS
FOR MAKING
POTS AND PANS FOR JEWISH MOMMA
WHICH SHE
OFTEN NEEDS FOR
JEWISH DINNERS.

BUT A CERTAIN POT
SHE'S GOT
IS EVEN BETTER.
THINK OF DOT.

IT'S GONNA MAKE
THE CHOSEN
PEOPLE WINNERS

'CAUSE WHEN ALL THE ENEMIES OF
JEWISH PEOPLE EVERYWHERE
DECIDE TO HAVE A POGROM
AND ATTACK

JEWS HAVE FINALLY GOT PROTECTION
THAT WILL MAKE THE BIG CORRECTION
AND WILL GET THE BASTARDS OFF THE JEWISH
 BACK!

LOOKIT THAT POT!
LOOK WHAT WE'VE GOT!
MIXING BOWL
FOR KEEPING JEWS ALL SAFE AND WHOLE!

A JEW ALONE COULD THINK OF THAT
MIRACULOUS INVENTION.
IT PUTS ALL OTHER HATS TO SHAME
FOR BEAUTY AND PROTECTION.

JUST LOOKIT HOW IT MAKES THE HEAD
BE SHINING PURE AND WHITE,

A MULTI-PURPOSE YARMULKE
TO PRAY WITH OR TO FIGHT.
BY FIGHTING, DOESN'T MEAN YOU HAVE
 TO GO OUT GIVING KNOCKS.
JUST SIT AT HOME WITH TORAH AND
 ABSORB THE WORST IN SHOCKS.

SO HIT THE JEW AGAINST THE HEAD,
 IT REALLY DOESN'T MATTER.
WITH POT PROTECTION, WHAT HE'S GOT
 IS LUXURY TO GATHER
THE JEWISH FAMILY ALL TOGETHER,
 ONCE AGAIN TO BE
THE PEOPLE OF THE BOOK WHO STAND
 OUTSIDE OF HISTORY.

CLARA:
OH, MIXING BOWL FOR ALL THE JEWS,
COME HOME AND MIX WITH ME—
THE BOWL YOU'LL GET FOR FREE,
A SPECIAL GIFT: YOU'LL BE
PROTECTED BY YOUR MOMMA'S BOWL,
REDEDICATE TO LEARNING
WHICH MAKES YOUR LIFE A SYMPHONY,
WHAT CALMS YOUR INNER CHURNING.

HOFFMEISTER:
SO JEWS CAN GET FROM HEAVEN
WHAT THEY USED TO GET BEFORE
—LIKE MANNA IN THE EXODUS
WAS FALLING ON THE FLOOR?
THOSE GREAT BIG BOWLS
WHERE GOD WAS MIXING
UP UNLEAVENED BREAD?
SO FINALLY
HE WASHED THE BOWLS
TO PLACE ON JEWISH HEADS!

MENDLE:

 OH JEWS THAT TO THE KINGDOM COME,
 YOU NOW AT LAST GOT POTS.
 WHICH FAR OUTVALUES ALL THE FINE
 POSSESSIONS THAT YOU GOT.

 YOUR FANCY CARS AND SWIMMING POOLS AND TV
 SETS AND JUNK,
 YOU'LL PILE THEM IN THE LIVING ROOM,
 YOU'LL SAY I'M IN A FUNK.
 BUT LET THEM SIT AND TURN TO SHIT; THAT'S
 WHAT THEY ARE INSIDE,
 WHILE YOU DRESS UP TO PLAY YOUR ROLE
 AS BRIDEGROOM OR AS BRIDE.

ALL:

 THE MARRIAGE THAT YOU'RE GOING TO MAKE
 IS WITH THE KING OF KINGS.
 WITH HIM YOU'LL SIT UPON A THRONE
 AND GIVE UP WORLDLY THINGS.
 YOUR CROWN WILL BE THE POT YOU SEE,
 PURE WHITE UPON THE HEAD.
 SO DO NOT LAUGH "THAT SILLY THING" FROM
 WHICH GOD'S PEOPLE FED.

 UPON YOUR HEAD, NOW MAKES YOU LOOK,
 TO SOME, A JEWISH CLOWN.
 BUT JEW, I'LL TELL THE SECRET
 WHEN THE GENTILES AIN'T AROUND!

 THE SILLY JEW IS ME AND YOU
 AND THAT'S THE SECRET HOW
 YOU GET YOURSELF TO PARADISE
 THE FOOL'S . . . THE WISE MAN NOW!

 SILLLLY . . . JEW
 SILLY . . . JEW
 DO THE DANCE

YOU CAN DO.
LET THE KINGDOM
REALLY COME.
BEING SMART
WITH BEING DUMB!

SILLY . . . POT
ON THE HEAD,
JOIN THE LIVING
WITH THE DEAD.

SILLY JEW
COULD BE YOU
WHO'S THE WISEST ONE, IT'S TRUE.
ALL YOU KNOW—WHAT'S IN YOUR NOGGIN,
AN' WHAT YOU DON'T KNOW—IN FACT
DAT'S THE
BIGGEST
PART OF DA BARGAIN!

HOFFMEISTER: Bargain? What bargain?

MENDLE: Shame, Hoffmeister. With *God!* The holy bargain!

HOFFMEISTER: God's talkin' from a bargain?

The Storyteller enters.

STORYTELLER *(What follows is sung/chanted)*:
DON'T TELL ME YOU'VE FORGOTTEN WHAT YOU'VE
KNOWN FROM LITTLE BOY.

HOFFMEISTER:
MY MEMORY MAYBE AIN'T NO MORE SO GOOD.

STORYTELLER:
I HOPE YOU READ THE TORAH, YOU A JEW OR YOU
A GOY?

HOFFMEISTER:
I READ IT, BUT NOT ALL I UNDERSTOOD.

MENDLE: So we'll refresh the memory?

STORYTELLER:

> SEEMS ONCE UPON A TIME THE LORD AND THE
> HOLY JEWISH PEOPLE
> SAT DOWN TO PLAN A VENTURE THEY COULD
> JOINTLY UNDERTAKE.
> THE GOOD LORD SAYS TO THEM, HEY LOOK, I GOT
> SOME NICE COMMANDMENTS,
> YOU FOLLOW THEM ALL FAITHFULLY, AND HERE'S
> THE DEAL I'LL MAKE:
> YOU'LL IN RETURN GET SOMETHING VERY GOOD!
> —SO THINK ABOUT THIS BARGAIN, WE CAN SEAL IT
> WITH A HANDSHAKE—
> IF I WAS YOU . . . I CERTAINLY WOULD.

HOFFMEISTER *(Interjects)*: So what happened?

STORYTELLER:

> WELL, SAYS THE JEWS, YOU SURE EXPLAINED THE
> BARGAIN.
> WELL, CERTAINLY, SAYS THE LORD, I THINK I
> EXPLAINED IT GOOD.
> IF I GET YOU, SAYS THE JEWS, MY PART OF THE
> BARGAIN IS—
> I DON'T DO THIS, AND I DON'T DO THAT—
> YEAH, THOSE JEWS *SURE* UNDERSTOOD!
> BUT THEN, SAYS THE JEWS—SO HOW ABOUT FOR
> *YOU?*
> LORD, I GOTTA BEG YOUR PARDON—
>
> BUT WHAT'S UP WITH *YOUR* END OF THE BARGAIN?

Pause.

WELL, SAYS THE LORD—

Spoken.

I'll tell you what, little Jews. My part of the bargain you're asking? Well, for that, little Jews—

Sings.

YOU! SHOULD! TRUST! IN GOD!

HOFFMEISTER: Trust. That's all? Just—we trust?

STORYTELLER: —Trust me . . .

Sings.

YOU! SHOULD! TRUST! IN GOD!

Spoken.

And guess what?

Sings.

THE GOOD LITTLE JEWS
THAT'S EXACTLY WHAT THEY DID,
FOR MANY, MANY YEARS
PRECISELY WHAT THEY DID.
THEY TRUSTED IN THE LORD
WITH MINIMUM COMPLAINING
'CAUSE THEY'RE ABSOLUTELY CERTAIN SOON
GOD'S BLESSING ON THEM WILL COME DOWN
 RAINING!

MENDLE *(Nods, interjects)*: —Any day now soon!

CHORUS:
SILLY JEWS,
HAPPY JEWS,

GET WHAT GOD
PROMISED YOU,

ALL YOUR DREAMS
COMING TRUE

JUST BECAUSE
YOU'RE A JEW.

SILLY JEWS,

CHOSEN ONES,
GOOD AS GOLD
'TIL YOU'RE OLD.

HAPPY JEWS
WIN THE PRIZE
WHEN IT COMES DOWN
FROM THE SKIES!

MENDLE: You won't believe your eyes!

CHORUS *(Big, slow)*: INTERJECTIONS *(On mike,*
 vaudeville style):

SILLY JEWS —smart Jews!
HAPPY JEWS —silly Jews!
'CAUSE YOU DID —lucky Jews!
WHAT YOU WERE TOLD —well, for the most part—

ALL THE GOOD THINGS YOU BEEN WAITIN'
WITH SUCH FOND ANTICIPATIN'
WILL BE COMING . . . SOON TO YOU
YOU—LUCKY—JEW!

Shouted over held note.

—And Jews, that you can rest
your bones is absolutely a
hundred percent promise for
counting on for sure 'til the
end of time is coming!

OH HAPPY JEW!!

—Probably next week some
time, it's almost a guarantee!

OH LUCKY JEWS!!

Hold last note, then cut into fast music for curtain calls.

THE END